UNITED STATES

UNITED STATES

LAURIE ANDERSON

HARPER & ROW, PUBLISHERS, New York, Cambridge, Philadelphia, San Francisco, London, Mexico City, São Paulo, Sydney

Photo credits appear on page 231.

FIRST EDITION

Designer: Barbara Richer

Library of Congress Cataloging in Publication Data

Anderson, Laurie, 1947-
 United States.

 1. Anderson, Laurie, 1947 . 2. United States in
art. 3. Performance art--Unites States. I. Title.
II. Title: U. S.
NX512.A54A4 1984 700'. 92'4 83–48315
ISBN 0–06–015243–5 84 85 86 87 88 10 9 8 7 6 5 4 3 2 1
ISBN 0–06–091110–7 (pbk.) 87 88 10 9 8 7 6 5 4 3 2

CONTENTS

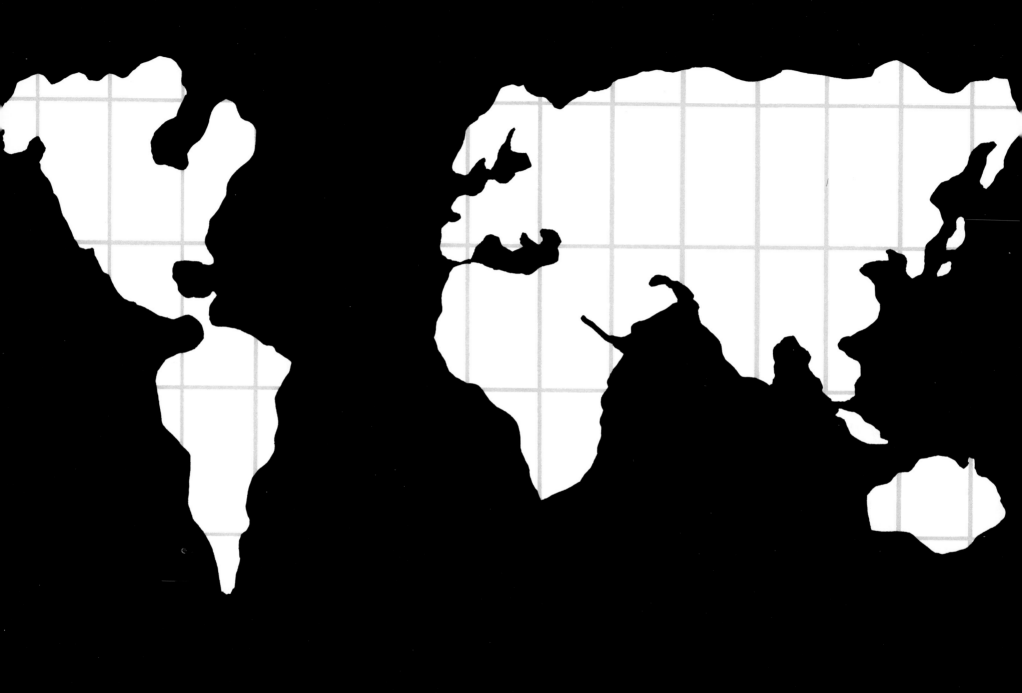

PART ONE

SAY HELLO

A certain American religious sect
has been looking at conditions of the
world during the Flood.
According to their calculations, during
the Flood
the winds, tides and currents were in
an overall southeasterly direction.
This would mean that in order for
Noah's Ark to have ended up on
Mount Ararat,
it would have to have started out
several thousand miles to the west.
This would then locate pre-Flood
civilization somewhere in the area of
Upstate New York,
and the Garden of Eden roughly in
New York City.

 Now, in order to get from one place
to another, something must move.
No one in New York remembers
moving,
and there are no traces of Biblical
history in the Upstate New York area.
So we are led to the only available
conclusion in this time warp, and that
is that
the Ark has simply not left yet.

Let's compare this situation to a familiar occurrence:
 You're driving alone at night.
 And it's dark
 and it's raining.
 And you took a turn back there
 and you're not sure now that it was the right turn,
 but you took the turn anyway
 and you just keep going in this direction.
 Eventually, it starts to get light and you look out
 and you realize
 you have absolutely no idea where you are.

So you get out at the next gas station and you say:

Hello. Excuse me. Can you tell me where I am?

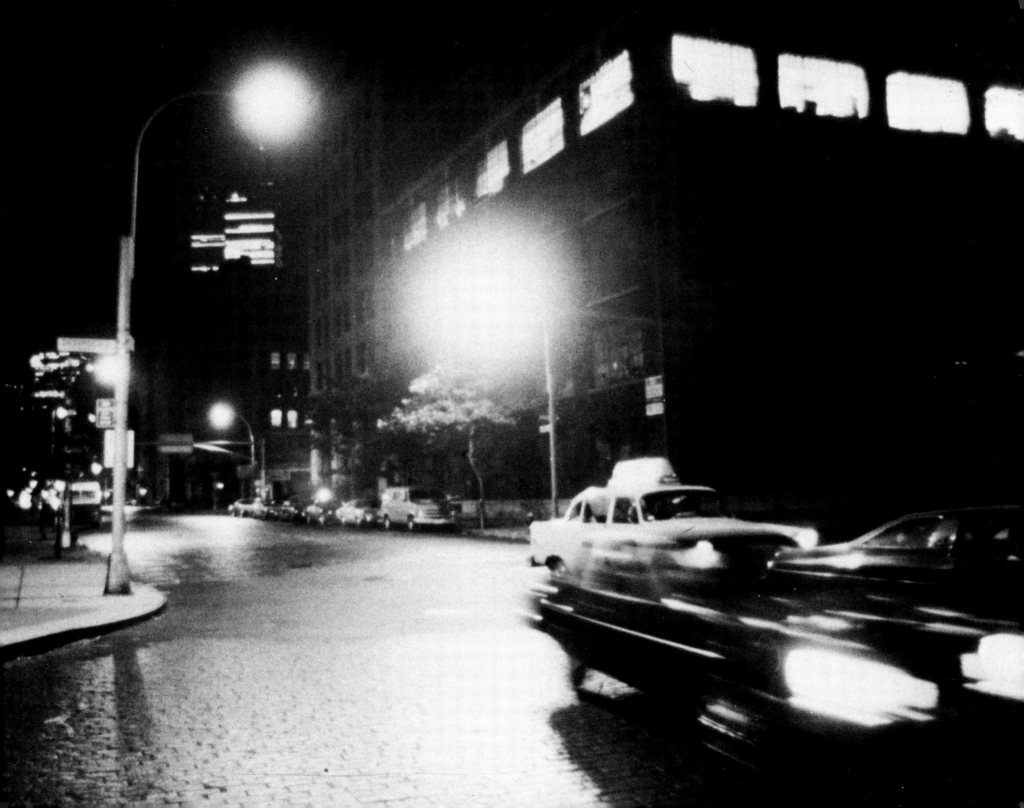

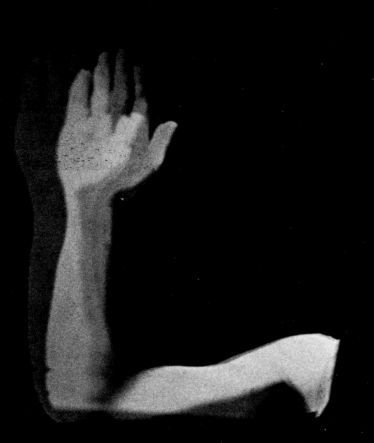

You can read the signs. You've been on this road before. Do you want to go home?

Do you want to go home now?

Hello. Excuse me. Can you tell me where I am?

You can read this sign language. In our country, this is the way we say Hello.

SAY HELLO.

Hello. Excuse me. Can you tell
me where I am?

In our country, this is the way we say Hello. It is a
diagram of movement between two points.
It is a sweep on the dial. In our country, this is also
the way we say Goodbye.

Hello. Excuse me. Can you tell me where I am?

In our country, we send pictures of people speaking our sign language in Outer Space. We are speaking our sign language in these pictures.

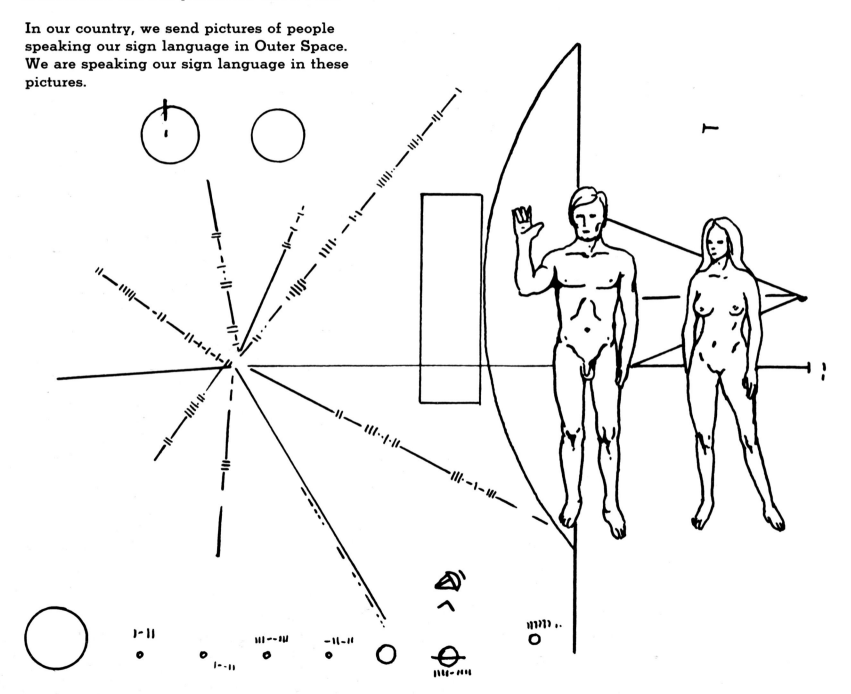

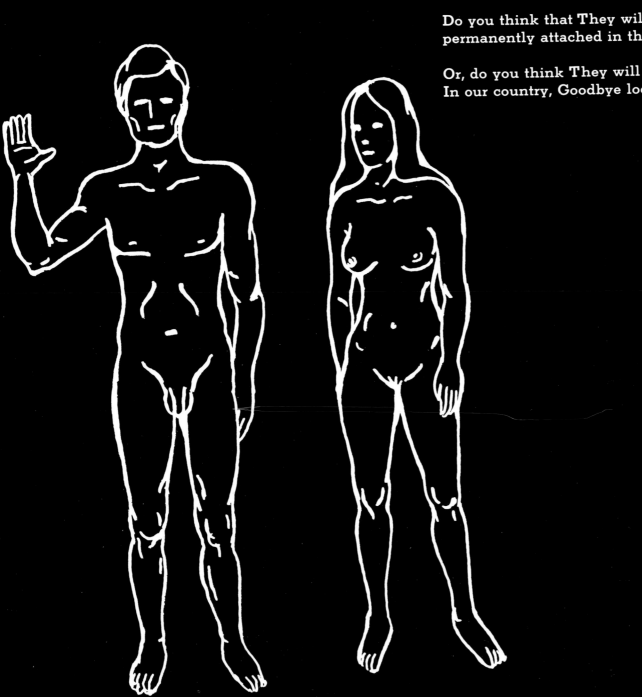

Do you think that They will think his arm is
permanently attached in this position?

Or, do you think They will read our signs?
In our country, Goodbye looks just like Hello.

SAY HELLO.

SAY HELLO.

SAY HELLO.

WALK THE DOG

Well, I saw a lot of trees today
and they were all made of wood.
They were wooden trees
and they were made entirely of wood.

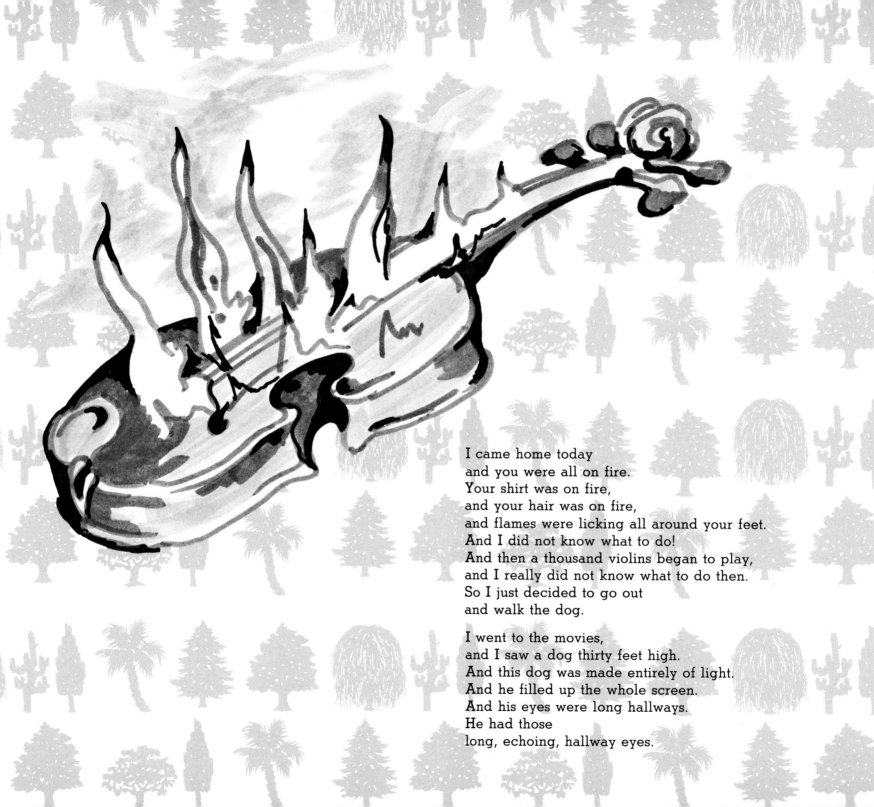

I came home today
and you were all on fire.
Your shirt was on fire,
and your hair was on fire,
and flames were licking all around your feet.
And I did not know what to do!
And then a thousand violins began to play,
and I really did not know what to do then.
So I just decided to go out
and walk the dog.

I went to the movies,
and I saw a dog thirty feet high.
And this dog was made entirely of light.
And he filled up the whole screen.
And his eyes were long hallways.
He had those
long, echoing, hallway eyes.

I turned on the radio
and I heard a song by Dolly Parton.
And she was singing:
Oh! I feel so sad! I feel so bad!
I left my mom and I left my dad.
And I just want to go home now.
I just want to go back to my Tennessee mountain
home now.
Well, you know she's not gonna go back home.
And I know she's not gonna go back home.
And she knows she's never gonna go back there.
And I just want to know who's gonna go and walk her dog.

Oh! I feel so bad.
I feel so sad.
But not as bad as the night
I wrote this song.

Close your eyes!

 OK.

Now imagine you're at the most wonderful
party.

 OK.

Delicious food.

 Uh huh.

Interesting people.

 Mm hmn.

Terrific music.

 Mn hmmh.

Now open them!

 Oh no.

Well, I just want to go home now
and walk the dog.

VIOLIN SOLO

CLOSED CIRCUITS

Well I know who you are, baby.
I've seen you go into that meditative state.
You're the snake charmer, baby.
And you're also the snake.
You're a closed circuit, baby.
You've got the answers in the palms of your hands.

Well I saw a blind Judge
and he said: I know who you are
and I said: Who?
And he said: You're a closed circuit, baby.
He said: The world is divided into two kinds of things.
There's luck, and there's the law.
There's a knock on wood that says: IT MIGHT.
And there's the long arm of the law that says: IT'S RIGHT.
And it's a tricky balancing act between the two because
both are equally true.
'Cause might makes right
and anything could happen. Che sarà sarà. Am I right?

Who? Do. Who? do.
Who do you love?

Well I saw a couple of hula dancers
just hula-ing down the street.
And they said: Well I wonder which way the tide
is gonna roll in tonight?
And I said: Hey hold up hula dancers! You know the
tide's gonna roll out
and then it's gonna roll right back in again.
'Cause it's a closed circuit, baby. We got rules for that
kind of thing
and you know the moon is so bright tonight.

Who? Do. Who? Do.
And don't think I haven't seen all those blind A-rabs
around. I've seen 'em around.
And I've watched them charm that oil
right out of the ground.
Long black streams of that dark electric light.
And they said: One day the sun went down
and it went way down, into the ground.
And three thousand years go by
and we pump it right back up again.
'Cause it's a closed circuit, baby.
We can change the dark into the light
and vice versa.

Well I know who you are, baby.
I've watched you count yourself to sleep.
You're the shepherd, baby,
And you're also one, two, three
hundred sheep. I've watched you fall asleep.

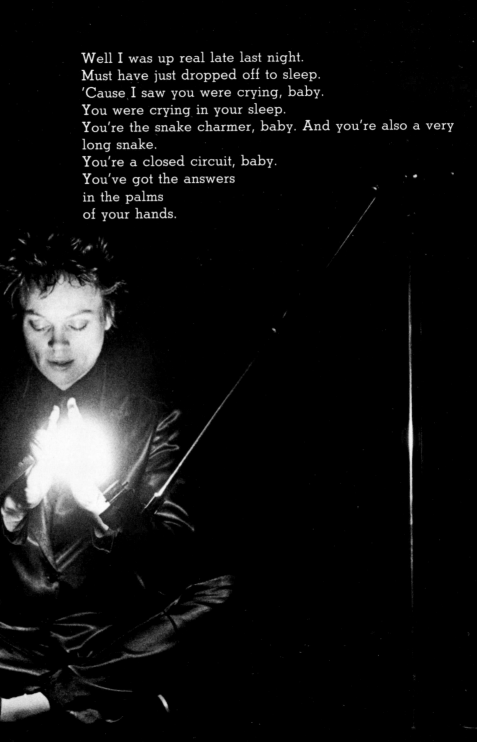

Well I was up real late last night.
Must have just dropped off to sleep.
'Cause I saw you were crying, baby.
You were crying in your sleep.
You're the snake charmer, baby. And you're also a very
long snake.
You're a closed circuit, baby.
You've got the answers
in the palms
of your hands.

TO A LARGE AND CHANGING ROOM

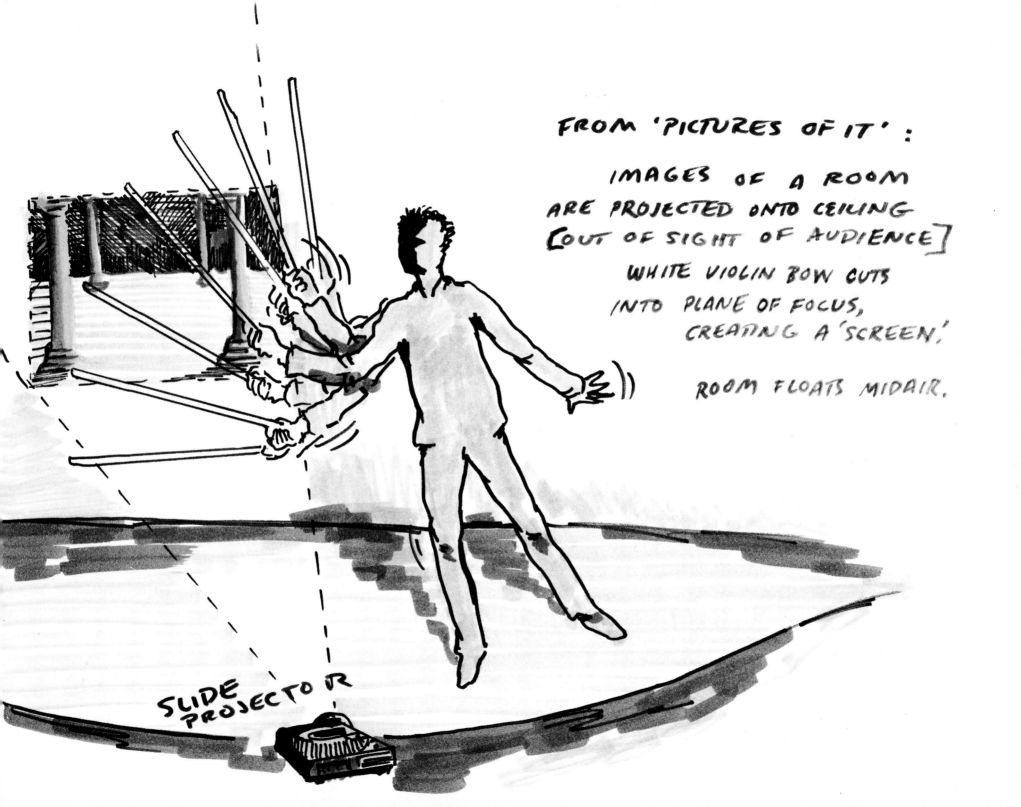

THE LANGUAGE OF THE FUTURE

Last year, I was on a twin-engine plane coming from
Milwaukee to New York City. Just over La Guardia, one
of the engines conked out and we started to drop
straight down, flipping over and over. Then the other
engine died: and we went completely out of control.
New York City started getting taller and taller. A voice
came over the intercom and said:

*Our pilot has informed us that we are about to
attempt*
a crash landing. Please extinguish all cigarettes.
Place your tray tables in their upright, locked
position.

Your Captain says: Please do not panic.

Your Captain says: Place your head
 in your hands.

Captain says: Place your head
 on your knees.

Captain says: Put your hands on your head.
 Put your hands on your knees!
 (heh-heh)

This is your Captain.
Have you lost your dog?
We are going down.
We are all going down, together.

As it turned out, we were caught in a downdraft and rammed into a bank. It was, in short, a miracle. But afterwards I was terrified of getting onto planes. The moment I started walking down that aisle, my eyes would clamp shut and I would fall into a deep, impenetrable sleep.

(YOU DON'T WANT TO SEE THIS . . .
YOU DON'T WANT TO BE HERE . . .
HAVE YOU LOST YOUR DOG?)

Finally, I was able to remain conscious, but I always had to go up to the forward cabin and ask the stewardesses if I could sit next to them: "Hi! Uh, mind if I join you?" They were always rather irritated—"Oh, all right (what a baby)"—and I watched their uniforms crack as we made nervous chitchat.

Sometimes even this didn't work, and I'd have to find one of the other passengers to talk to. You can spot these people immediately. There's one on every flight. Someone who's really on *your* wavelength.

I was on a flight from L.A. when I spotted one of them, sitting across the aisle. A girl, about fifteen. And she had this stuffed rabbit set up on her tray table and she kept arranging and rearranging the rabbit and kind of waving to it: "Hi!"
"Hi there!"

And I decided: This is the one *I* want to sit next to. So I sat down and we started to talk and suddenly I realized she was speaking an entirely different language. Computerese.
A kind of high-tech lingo.
Everything was circuitry, electronics, switching.
If she didn't understand something, it just "didn't scan."

We talked mostly about her boyfriend. This guy was never in a bad mood. He was in a bad mode.
Modey kind of a guy.
The romance was apparently kind of rocky and she kept saying: "Man oh man you know like it's so digital!" She just meant the relationship was on again, off again.

Always two things
switching.
Current runs through bodies
and then it doesn't.
It was a language of sounds,
of noise,
of switching,
of signals.
 It was the language of the rabbit,
 the caribou,
 the penguin,
 the beaver.
A language of the past.
Current runs through bodies
and then it doesn't.
On again.
Off again.
Always two things
switching.
One thing instantly replaces
another.

It was the language
of the Future.

Put your knees
up to your chin.
Have you lost your dog?
Put your hands
over your eyes.

Jump out of the plane.
There is no
pilot.
You
are not
alone.

This
is the language
of the on-again
off-again
future.
And
it is Digital.

And I answered the phone and I heard a voice and the
voice said:

Please do not hang up.
We know who you are.
Please do not hang up.
We know what you have to
say.
Please do not hang up.
We know what you want.
Please do not hang up.
We've got your number:
One . . .
Two . . .
Three . . .
Four.

R ING

R ING

W ARE IN LINE

WE ARE A PING YOUR LI E

WE ARE TA PING YOUR LI E

WE ARE TAPPING YOUR LINE

PILLOW SPEAKER
(IN MOUTH) RUNS TO CONCEALED
CASETTE DECK WHICH PLAYS TAPE
OF VIOLIN SOLO.
 VIOLIN COMING FROM THE
MOUTH IS PHRASED + MODULATED
BY THE LIPS.

CASETTE
DECK

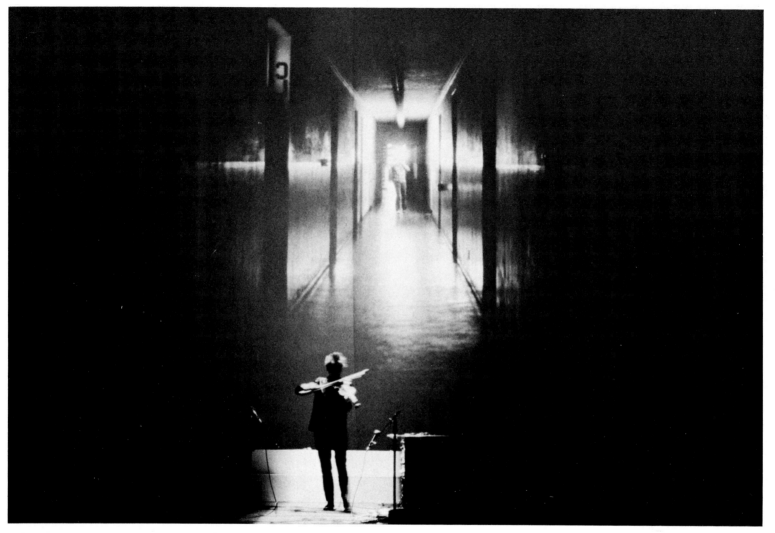

THREE WALKING SONGS

I saw a man on the Bowery and he was wearing ancient,
greasy clothes and brand-new bright white socks and no
shoes.
Instead, he was standing on two small pieces of plywood
and as he moved along the block, he bent down,
moved one of the pieces slightly ahead
and stepped on it.
Then he moved the other piece slightly ahead
and stepped on it.

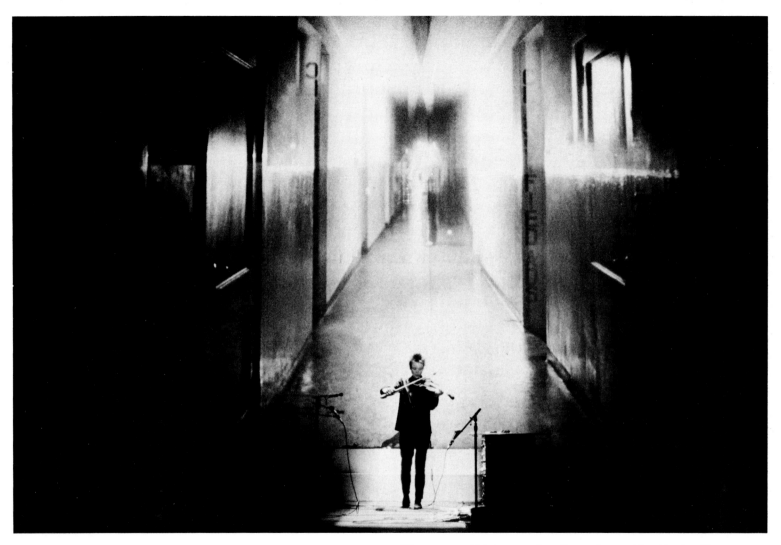

There are Eskimos who live above the timberline.
There's no wood for the runners on their sleds. So
instead, they use long frozen fish which they attach to
the bottoms of their sleds to slip across the snow.

I saw a photograph of Tesla, who invented the Tesla coil. He also invented a pair of shoes with soles four inches thick to ground him while he worked in the laboratory. In this picture, Tesla is sitting in his lab, wearing the shoes, and reading a book by the light of the long, streamer-like sparks shooting out of his transformers.

THE HEALING HORN

When I was in L.A. I went to several services run by an organization called the Universalist World Church. The services were held in a huge auditorium, formerly a used-car showroom. The head of this operation was a man named Dr. J., an Egyptologist, preacher and recording artist. At the back of the church he sold cassettes he had produced in his home studio. The cassettes had titles like: "UFOs and the Creatures Who Drive Them." His assistant was a tiny woman named Miss Velma, a soprano who also administered the Oil of Youth at the Healing Horn. The Healing Horn was an actual horn of identifiable origins all set in jewels. When you touch the horn you feel a rejuvenating surge of energy, about fifty volts, as long as you happen to be standing on the metal plate embedded in the altar.

The most spectacular event of the year at the World Church was a Christmas service. There was a giant screen painted with a Nativity scene. There were lots of animals painted on the screen, with holes cut out where their heads would be; there was a microphone behind each hole. During the service, Miss Velma would stand behind the screen and stick her head through these holes, using a different voice for each animal. "Hi. I'm the cow and I saw it all." "Hello. I'm the dove. The lovely dove. And I was there too. I saw everything too."

The service would then abruptly cut to Dr. J., who would announce, "First, Miss Velma will shoot an arrow through a balloon. Then she will perform an Indian dance. And finally, she will perform a song for you on the mellophone." With no further explanation, Miss Velma comes out from behind the screen. First she shoots an arrow through a balloon. Then she does an Indian dance. And last, she performs a song on the mellophone.

And somehow it was amazing. First he tells you what will happen and then it actually happens, just the way he said it would. Like a prophecy being fulfilled.

NEW JERSEY TURNPIKE

It is against the rules and regulations of the New Jersey Turnpike Authority to drive in the wrong direction on the New Jersey Turnpike.

It is against the rules and regulations of the New Jersey Turnpike Authority to drive in the right direction in reverse on the New Jersey Turnpike.

It is against the rules and regulations of the New Jersey Turnpike Authority to drive herds of hooven animals on the New Jersey Turnpike.

It is against the rules and regulations of the New Jersey Turnpike Authority to drive vehicles with metal tires on the New Jersey Turnpike.

It is against the rules and regulations of the New Jersey Turnpike Authority
to drive in the wrong direction on the entrance and exit ramps
of the New Jersey Turnpike.

It is against the rules and regulations of the New Jersey Turnpike Authority
to drive in the right direction in reverse on the entrance and exit ramps
of the New Jersey Turnpike.

It is against the rules and regulations of the New Jersey Turnpike Authority
to drive herds of hooven animals on the entrance and exit ramps
of the New Jersey Turnpike.

It is against the rules and regulations of the New Jersey Turnpike Authority
to drive vehicles with metal tires on the entrance and exit ramps
of the New Jersey Turnpike.

PETER: There was an old couple who decided to drive cross country in their car. Both of them were almost legally deaf. About ten miles away from home, the burglar alarm for their car door went off and got stuck in the "on" position. They drove all the way to San Francisco like this. You could hear them coming from three miles away.

 The alarm didn't seem to bother the old woman at all. She thought it was sort of pleasant. Near Chicago, she said to her husband, "It sounds like faraway bees on a summer day." Her husband said, "What?"

LAURIE: You can read the signs. You've been on this road before. Do you want to go home? Do you want to go home now?

P: One of the major airlines used to run a kind of lottery, mostly to give passengers something to do while the plane was waiting in line on the runway. The stewardess would hand out lottery tickets and you peeled the sticker away. If you had the right combination of numbers, you won a free trip to Hawaii. If you didn't, you didn't win a free trip. The airline discontinued the game when there were too many complaints about the timing of the lottery. They said:

 Our surveys tell us that our customers felt that waiting on the runway was the wrong time to play a game of chance.

L: In my dream, I am your customer, and the customer is always right.

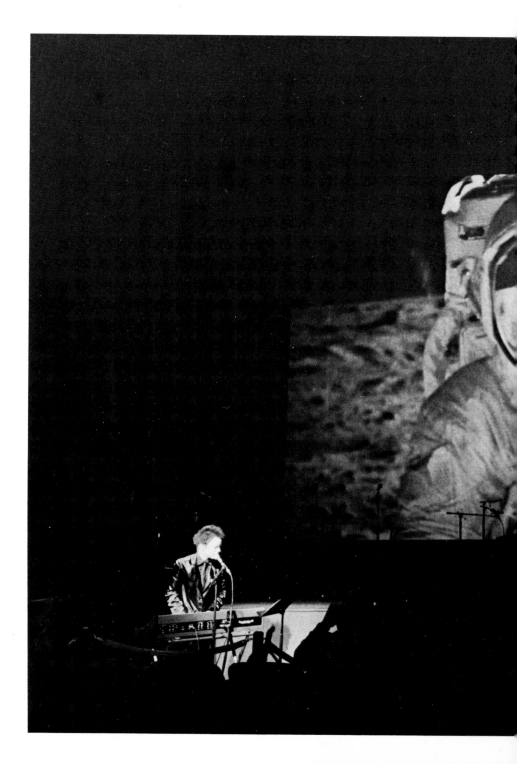

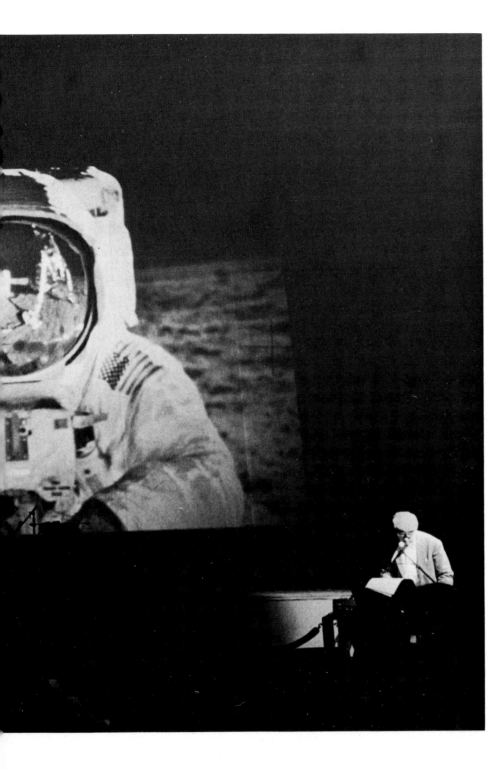

P: He said, You know, to be *really* safe you should always carry a bomb on an airplane. Because the chances of there being *one* bomb on a plane are pretty small. But the chances of *two* bombs are almost minuscule. So by carrying a bomb on a plane, the odds of your becoming a hostage or of getting blown up are astronomically reduced.

L: You're driving and you're talking to yourself and you say to yourself: Why these mountains? Why this sky? Why this road? This big town. This ugly train.

P: In our eyes. And in our wives' eyes. In our arms and (I might add) in our wives' arms.

L: How come people from the North are so well organized, industrious, pragmatic and—let's face it—preppy? And people from the South are so devil-may-care? Every man for himself.

P: I know this English guy who was driving around in the South. And he stopped for breakfast one morning somewhere in southeast Georgia. He saw "grits" on the menu. He'd never heard of grits so he asked the waitress, "What are grits, anyway?" She said, "Grits are fifty." He said, "Yes, but what *are* they?" She said, "They're extra." He said, "Yes, I'll have the grits, please."

L: Over the river, and through the woods. Let me see that map.

P: A sideshow. A smokescreen. A passing landscape.

L: I was living out in West Hollywood when the Hollywood Strangler was strangling women. He was strangling women all over town, but he was particularly strangling them in West Hollywood. Every night there was a panel discussion on TV about the strangler—speculations about his habits, his motives, his methods. One thing was clear about him: He only strangled women when they were alone, or with other women. The panel members would always end the show by saying, "Now, for all you women, listen, don't go outside without a man. Don't walk out to your car, don't even take out the garbage by yourself. Always go with a man." Then one of the eyewitnesses identified a policeman as one of the suspects. The next night, the chief of police was on the panel. He said, "Now, girls, whatever happens, do not stop for a police officer. Stay in your car. If a police officer tries to stop you, do not stop. Keep driving and under no circumstances should you get out of your car." For a few weeks, half the traffic in L.A. was doing twice the speed limit.

P: I remember when we were going to go into outer space. I remember when the President said we were going to look for things in outer space. And I remember the way the astronauts talked and the way everybody was watching because there was a chance that they would burn up on the launching pad or that the rocket would take off from Cape Canaveral and land in Fort Lauderdale five minutes later by mistake. And now we're not even trying to get *that* far. Now it's more like the bus. Now it's more like they go up just high enough to get a good view. They aim the camera back down. They don't aim the camera up. And then they take pictures and come right back and develop them. That's what it's like now. Now that's what it's like.

L: Every time I hear a fire engine it seems like the trucks are running away from the fire. Not towards it. Not right into it. They seem like monsters in a panic —running away from the fire. Stampeding away from the fire. Not towards it. Not right into it.

P: In Seattle, the bus drivers were out on strike. One of the issues was their refusal to provide a shuttle service for citizens to designated host areas in the event of a nuclear attack on Seattle. The drivers said, "Look, Seattle will be a ghost town." They said, "It's a one-way trip to the host town, we're not driving back to that ghost town."

L: A city that repeats itself endlessly. Hoping that something will stick in its mind.

SO HAPPY BIRTHDAY

JOE: In our country, you're free and so you're born and so they say, "You're free," so happy birthday. And even if you were born to lose—even if you were a complete wreck when you were born—you might still grow up to be president . . . because you're free.

GERALDINE: Today, you might be an average citizen . . . a civilian . . . a pedestrian . . . But tomorrow you might be elected to some unexpected office—or sell your novel and suddenly become famous. Or you could get run over by a truck and your picture could get into the papers *that* way, Because you're free and anything might happen . . . so happy birthday.

J: Gee! All those lights and all those screens! The New York Experience is mind-boggling. I don't think I've ever seen that many screens and I'll probably come again. . . . It was really amazing, mind-boggling.

G: You're walking and you don't always realize it but you're always falling at the same time. With each step you fall forward. Over and over, you're falling and then catching yourself from falling. . . . And this is how you can be walking and falling at the same time.

J: Look! Over there! It's a real dog . . . and it's really talking.

G: I wanted you and I was looking for you . . . but I couldn't find you. I wanted you and I was looking for you all day . . . but I couldn't find you.

J: Well, I paid my money, and I've got this funny feeling that somehow—you know—it's not what I paid my money for. I mean I *paid* my money and I just don't think this is what I paid my money—you know—what I paid my money for.

G: No one has ever looked at me like this before . . . no one has ever *stared* at me for so long like this. . . . This is the first time anyone has ever looked at me like this . . . stared at me like this for such a long time . . . for so long.

J: Well, he didn't know what to do so he just decided to watch the government and see what the government was doing and then kind of scale it down to size— and run his life that way.

G: She said the hardest thing to teach her three-year-old kid was what was alive and what wasn't. The phone rings and she holds it out to her kid and says, "It's Grandma. Talk to Grandma." But she's holding a piece of plastic. And the kid says to herself: "Wait a minute. Is the phone alive? Is the TV alive? What about that radio? What is alive in this room and what doesn't have life?" Unfortunately, she doesn't know how to ask these questions.

J: We were in a large room. Full of people. All kinds. And they had arrived at the same time. And they were all free and they were all asking themselves the same question: What is behind that curtain? They were all free. And they were all wondering what would happen next.

G: This is the time
and this is the record of the time.
This is the time
and this is the record of the time.

EngliSH

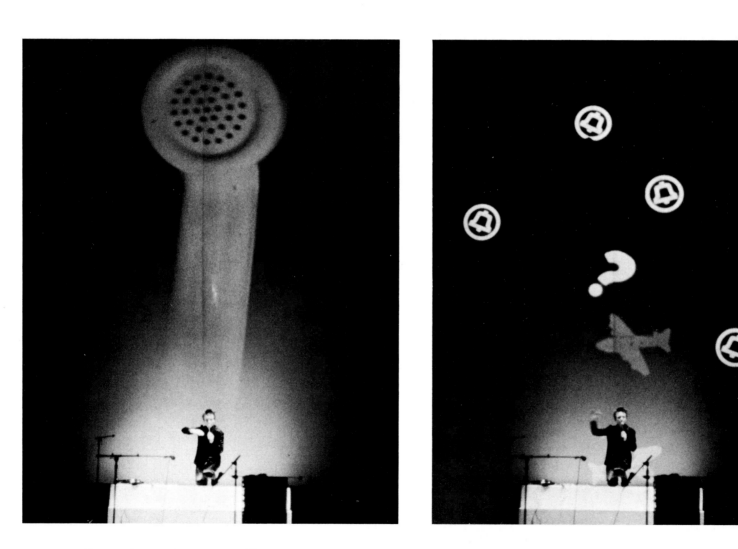

SH SH SH EngliSH... FrenSH... SpaniSH... DeutSH... DutSH... YiddiSH...

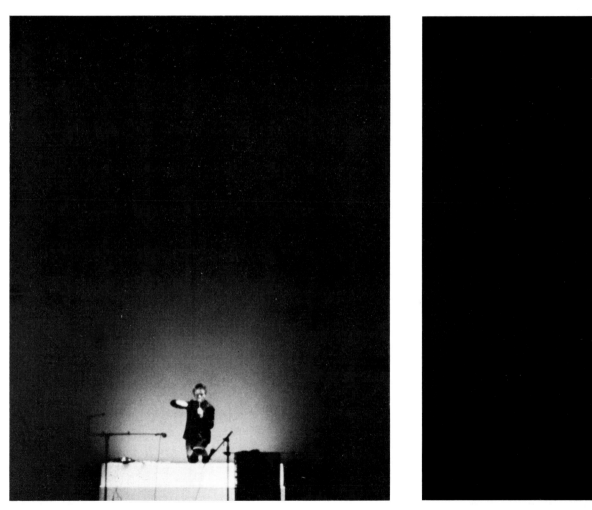

RusSHian... SHinese... PoliSH... SwediSH... FinniSH... FinniSH... FinniSH...

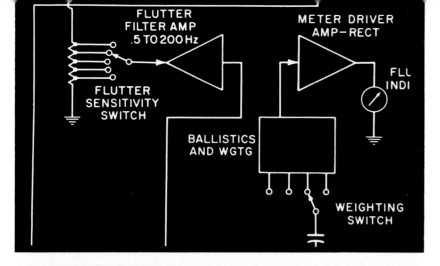

DANGER OF ELECTRICITY (FOR NIKOLA TESLA)

A while ago, I got a call from the Tesla Institute in Belgrade, long distance. The voice was very faint and it said, "Understand do we that much of your work has been dedicated to Nikola Tesla and do we know the blackout of information about this man in the U.S. of A. And so we would like to invite you to the Institute as a free citizen of the world . . . as a free speaker on American Imperialist Blackout of Information . . . Capitalist resistance to Technological Progress . . . the Western World's obstruction of Innovation. So think about it." He hung up. I thought: Gee, really a chance to speak my mind, and I started doing some research on Tesla, whose life story is actually really sad.

Basically, he was the inventor of AC current, lots of kinds of generators and the Tesla coil. His dream was wireless energy. And he was working on a system in which you could plug appliances directly into the ground. A system which he never really perfected.

Tesla came over from Graz and went to work for Thomas Edison. Edison couldn't stand Tesla for several reasons. One was that Tesla showed up for work every day in formal dress—morning coat, spats, top hat and gloves—and this just wasn't the American Way at the time. Edison also hated Tesla because Tesla invented so many things while wearing these clothes.

Edison did his best to prevent conversion to AC and did everything he could to discredit it. In his later years, Edison was something of a showman and he went around on the Chautauqua circuit in upstate New York giving demonstrations of the evil effects of AC. He always brought a dog with him and he'd get up on stage and say: "Ladies and gentlemen! I will now demonstrate the effects of AC current on this dog!" And he took two bare wires and attached them to the dog's head and the dog was dead in under thirty seconds.

At any rate, I decided to open the series of talks in Belgrade with a song called "The Dance of Electricity" and its beat is derived from an actual dance—an involuntary dance—and it's the dance you do when one of your fingers gets wedged in a live socket and your arms start pumping up and down and your mouth is slowly opening and closing and you can feel the power but no words will come out.

The detective novel is the only novel truly invented in the twentieth century. In the detective novel, the hero is dead at the very beginning. So you don't have to deal with human nature at all. Only the slow accumulation of facts . . . of data . . .

In science fiction films, the hero just flies in at the very beginning. He can bend steel with his bare hands. He can walk in zero gravity. He can see right through lead doors. But no one asks how he is able to do these things. They just say, "Look! He's walking in zero gravity." So you don't have to deal with human nature at all.

L: When TV signals are sent out, they
don't stop. They keep going. They pick
up speed as they leave the solar system.
By now, the first TV programs ever made
have been traveling for thirty years.
They are well beyond our solar system
now. All those characters from cowboy
serials, variety hours and quiz shows are
sailing out. They are the first true voyag-
ers into deep space. And they sail farther
and farther out, intact, still talking.

And as we listen with our instruments, as
we learn to listen farther and farther into
space, we can hear them. We listen far-
ther and that is all we hear. They are
jamming our lines. We listen and we
hear them talking, traveling, going faster
and faster . . . getting fainter and fainter.
And as our instruments become more so-
phisticated, we can hear them better
. . . speeding away . . . the sound of
speeding away . . . like a phone continu-
ously ringing.

BORN, NEVER ASKED

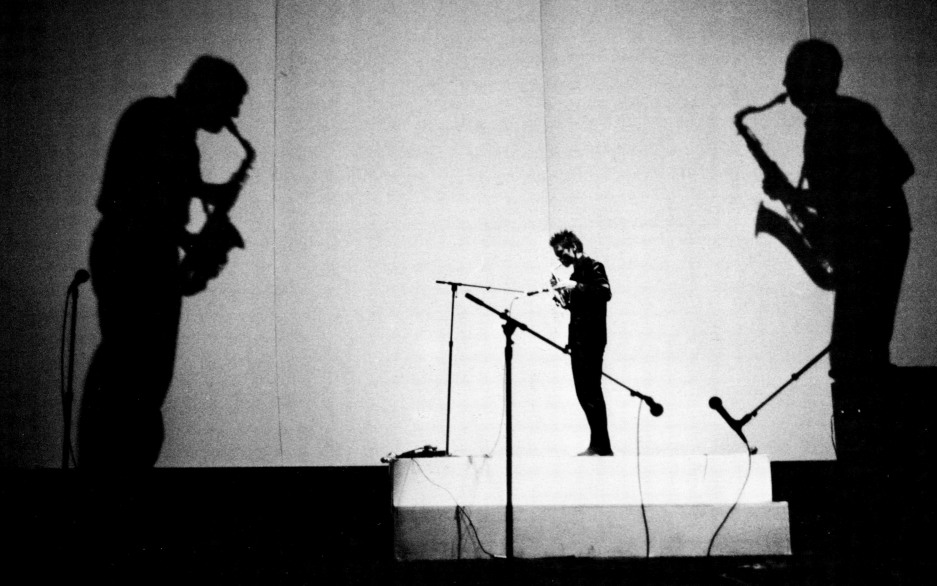

SAX TRIO

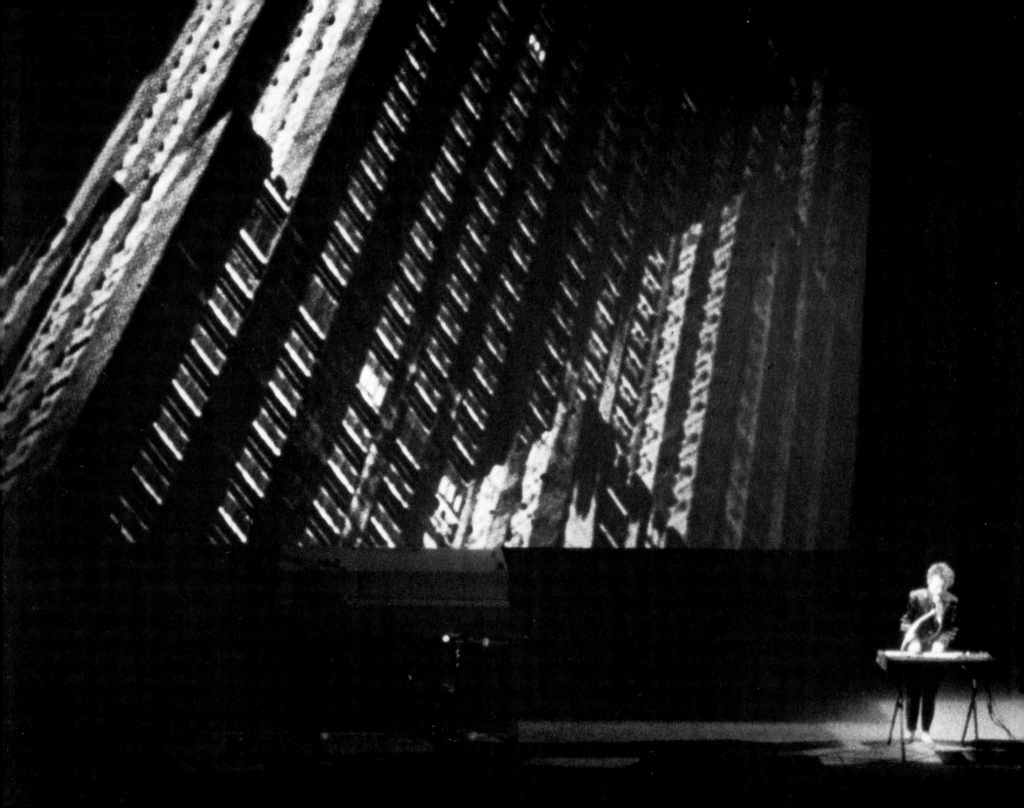

PART TWO

FROM THE AIR

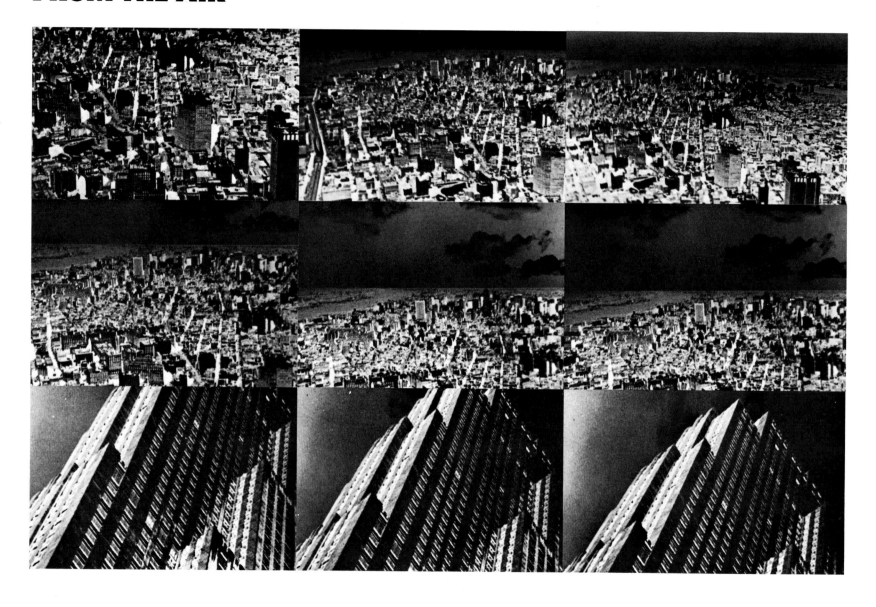

BEGINNING FRENCH

Lately, I've been doing a lot of concerts in French. Unfortunately, I don't speak French. I memorize it. I mean, my mouth is moving but I don't understand what I'm saying.

It's like sitting at the breakfast table and it's early in the morning and you're not quite awake. And you're just sitting there eating cereal and sort of staring at the writing on the box—not reading it exactly, just more or less looking at the words. And suddenly, for some reason, you snap to attention, and you realize that what you're reading is what you're eating . . . but by then it's much too late.

After doing these concerts in French, I usually had the temporary illusion that I could actually speak French, but as soon as I walked out on the street, and someone asked me simple directions, I realized I couldn't speak a single word. As a result of this inadequacy, I found that the people I had the most rapport with there were the babies. And one of the things I noticed about these babies was that they were apparently being used as some kind of traffic testers. Their mothers would be pushing them along in their strollers—and they would come to a busy street with lots of parked cars—and the mother can't see what the traffic is like because of all the parked cars—so she just sort of edges the stroller out into the street and cranes her head out afterwards. And the most striking thing about this is the expression on these babies' faces as they sit there
in the middle of traffic
stranded
banging those little gavels they've all got
and they can't even speak English.
Do you know what I mean?

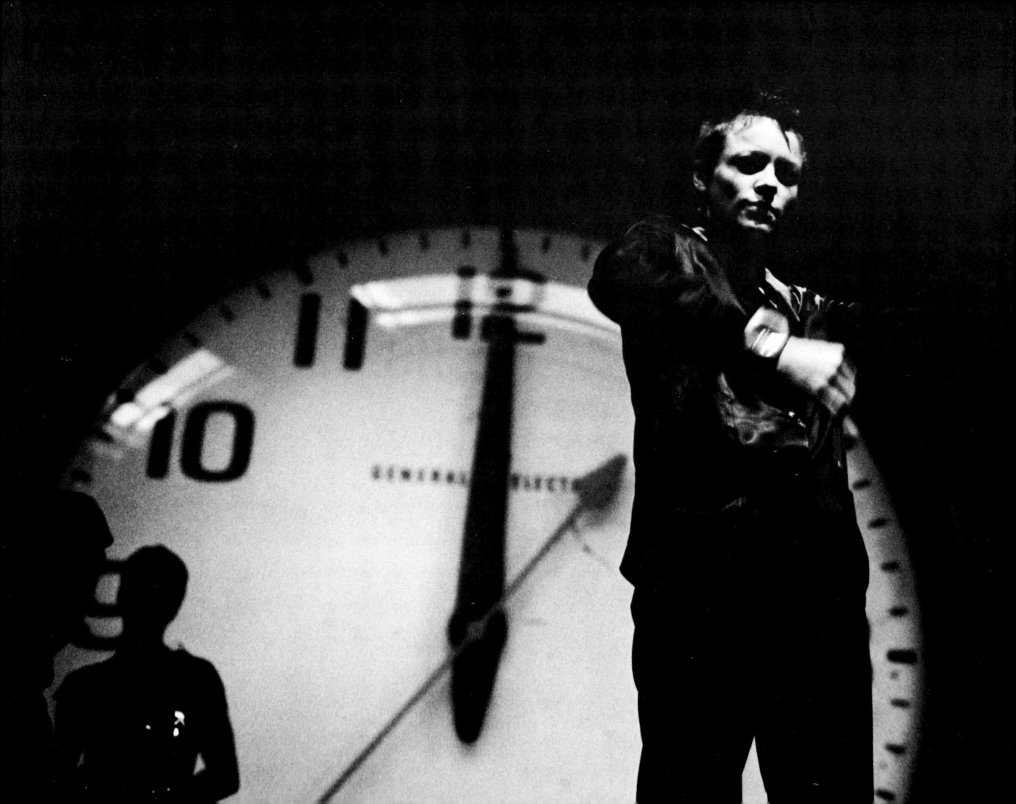

The hammer strikes. Its bang is memorized by a harmonizer and repeated. Strike and repeat. Like a ticking watch.

Violin Pantomime

O SUPERMAN (FOR MASSENET)

O Superman. O Judge. O Mom and Dad.
O Superman. O Judge. O Mom and Dad.

Hi. I'm not home right now. But if you want to leave a
message, just start talking at the sound of the tone.

Hello? This is your mother. Are you there? Are you
coming home?
Hello? Is anybody home?

Well you don't know me
but I know you.
And I've got a message to give to you.
Here come the planes.

So you better get ready
ready to go.
You can come as you are
but pay as you go.
Pay as you go. . . .

And I said: OK! Who is this really?

And the voice said:
This is the hand, the hand that takes.
This is the hand. The hand that takes. . . . Here come
the planes.
They're American planes, made in America. Smoking or
nonsmoking?

And the voice said:
Neither snow nor rain
nor gloom of night
shall stay these couriers
from the swift completion
of their appointed rounds.

'Cause when love is gone
there's always justice,
and when justice is gone
there's always force,
and when force is gone,
there's always Mom.
Hi Mom!

So hold me Mom
in your long arms . . .
So hold me Mom, in your long arms,
in your automatic arms,
your electronic arms,
in your arms . . .
So hold me Mom, in your long arms,
your petrochemical arms,
your military arms,
in your electronic arms . . .

TALKSHOW

During the newspaper strike, the networks asked the writers to read their columns on TV. The writers weren't actors, they did all the wrong things they squinted into the . . . lights, wore rumpled! clothes and used BIGWORDS the signs for the deaf were getting more and "more" obscure with lots of qualifying (phrases) and . . . uh . . . awkward . . . pauses so the producers kept saying:

OK! Buzz words only! Two syllables:

tops!

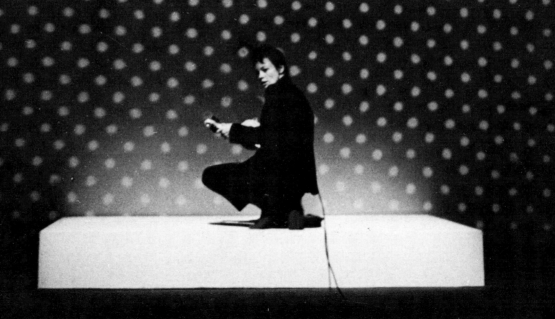

 Talkshow

 Uplink

Update

 Phaselock

 Downtime

 Hotline

 Aftermath

 Upshot

 Dropout

 Nosecone

 Headset

 Hotshot

 Heatwave

 Domehead

 Flashback

 Feedback

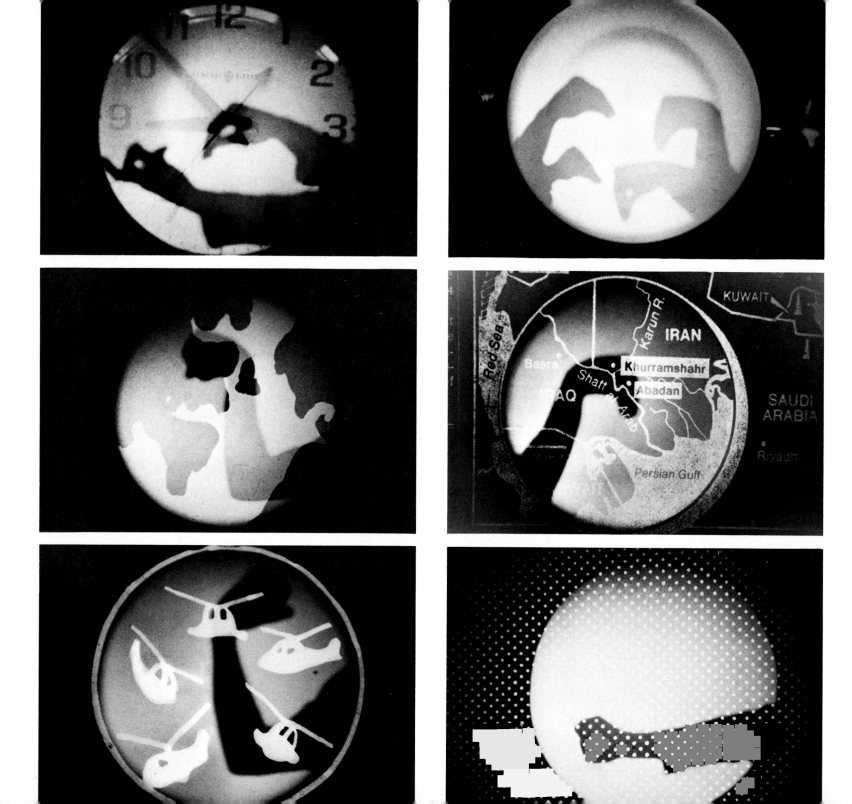

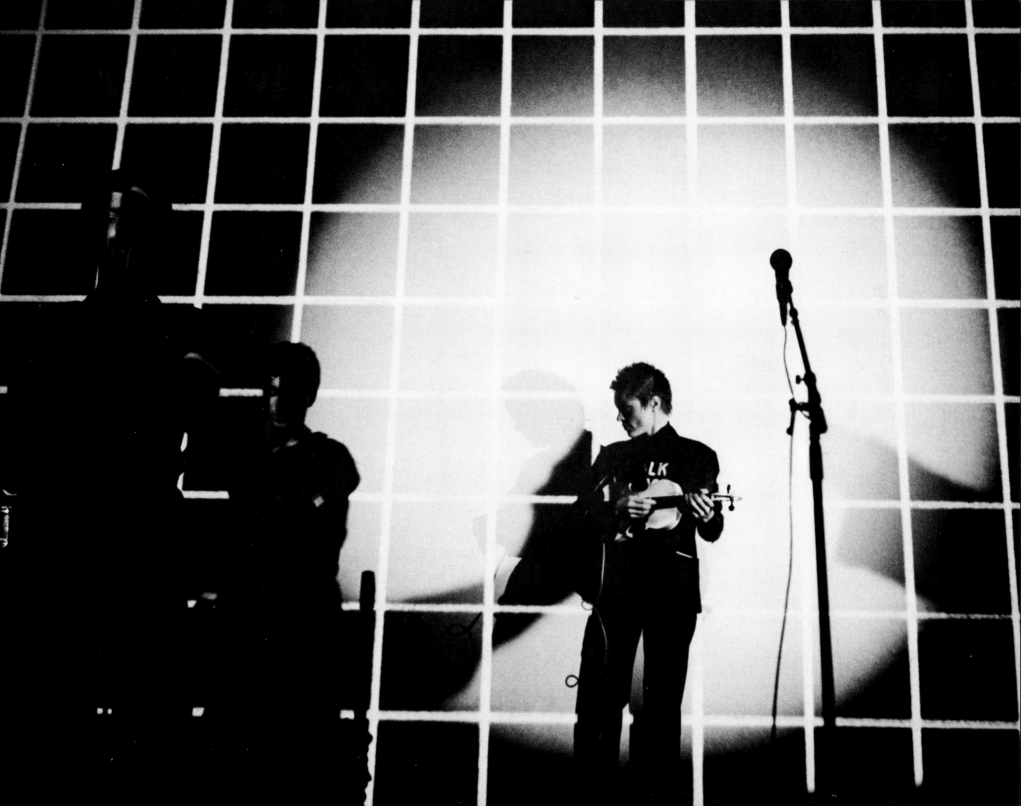

FRAMES FOR THE PICTURES

I had this dream . . . and in it my mother is sitting there cutting out pictures of hamsters from magazines. In some of the pictures, the hamsters are pets, and in some of them, hamsters are just somewhere in the background. And she's got a whole pile of these cedar chips—you know the kind: the kind from the bottoms of hamster cages—and she's gluing them together into frames for the pictures. She glues them together, and frames the pictures, and hangs them up over the fireplace—that's more or less her method. And suddenly I realize that this is just her way of telling me that I should become a structuralist filmmaker—which I had, you know, planned to do anyway. . . .

DEMOCRATIC WAY

I dreamed that I was Jimmy Carter's lover, and I was some-
where, I guess in the White House . . . and there were lots
of other women there, too . . . and they were supposed to
be his lovers too . . . but I never even saw Jimmy Carter
. . . and none of the other women ever saw him either.
. . .

And there was this big discussion going on because Jimmy
had decided to open up the presidential elections to the
dead. That is, that anyone who had ever lived would have
the opportunity to become President. He said he thought it
would be more democratic that way.

The more choice you had

the more democratic it would be.

LOOKING FOR YOU; WALKING AND FALLING

I wanted you . . . and I was looking for you . . . but I
couldn't find you . . .
I wanted you. And I was looking for you all day. But I
couldn't find you. I couldn't find you.

You're walking

and you don't always realize it
 but you're always
 falling.
 With each step,
 you fall
 slightly
 forward
 and then
 catch yourself
 from falling.
 Over
 and
 over,
 you're falling
 and then catching yourself from
 falling.
 And this is how you can be walking
 and falling
 at the same time.

RED HOT

My sister and I used to play this game called Red Hot.

And in Red Hot, the ceiling is suddenly about a

thousand degrees.

And there's no gravity.

Gravity doesn't exist anymore.

And you're trying not to float up to the ceiling

so you have to hold on to things.

You have to hold on to sheets, pillows, chairs,

anything so that you won't go floating up to that ceiling.

I guess it's not what anyone would call a very

competitive game.

You know what I mean?

Mainly, we just sweated a lot

and we were really glad when it was all over

and the ceiling cooled back down again.

PRIVATE PROPERTY

William F. Buckley, Jr., Mr. Private Property, planned to
give a little talk, a political speech, in a small town in
Illinois. His advance men discovered that the center of
town had disappeared, and that all the commercial action
was out at the mall. When Buckley arrived at the mall, he
set up his microphone near a little fountain and began to
hand out leaflets and autograph copies of his latest book.
Just as a small crowd of shoppers gathered, the owners of
the mall ran out and said: Excuse us. This is private prop-
erty, we're afraid you'll have to leave. . . .

You know, when I got back from a trip this summer, I noticed that all of the old factories here on the outskirts of town had suddenly been transformed into luxurious condos and that thousands of people had moved into them almost overnight. Most of the new residents appeared to be professional barbecuers. Every night, they were out on their fire escapes barbecueing something. And the smoke rising from their little fires made the whole neighborhood look like a giant battlefield. And I would look out my window and say: Hm. You know, last night I came up out of the subway and I said to myself: Hm. Do you want to go home? And I thought: You *are* home.

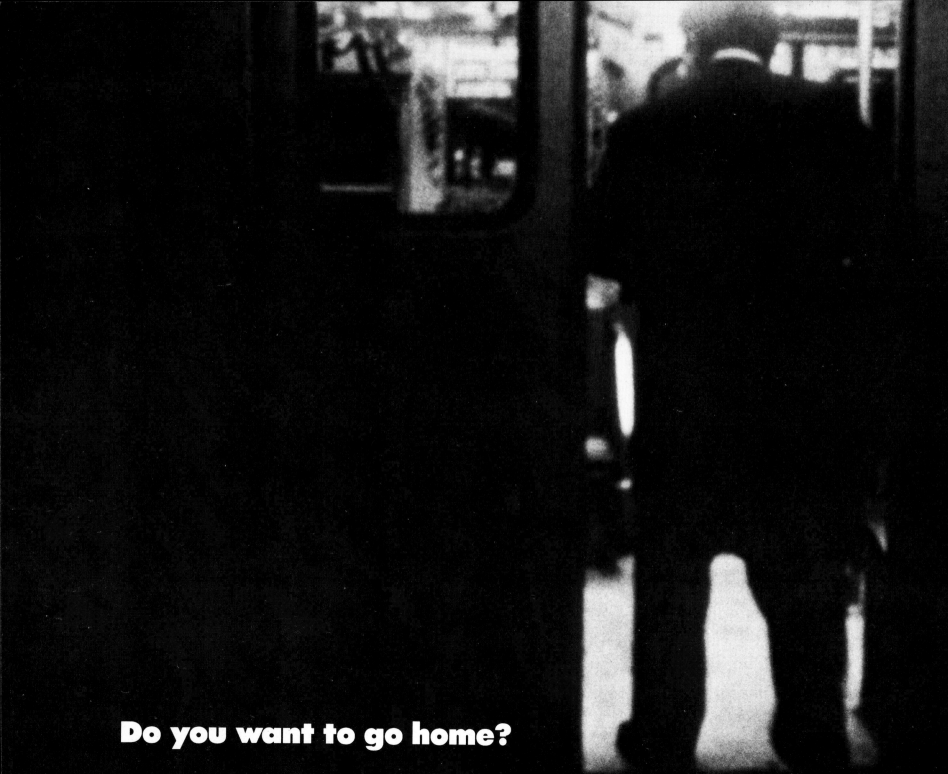

Do you want to go home?

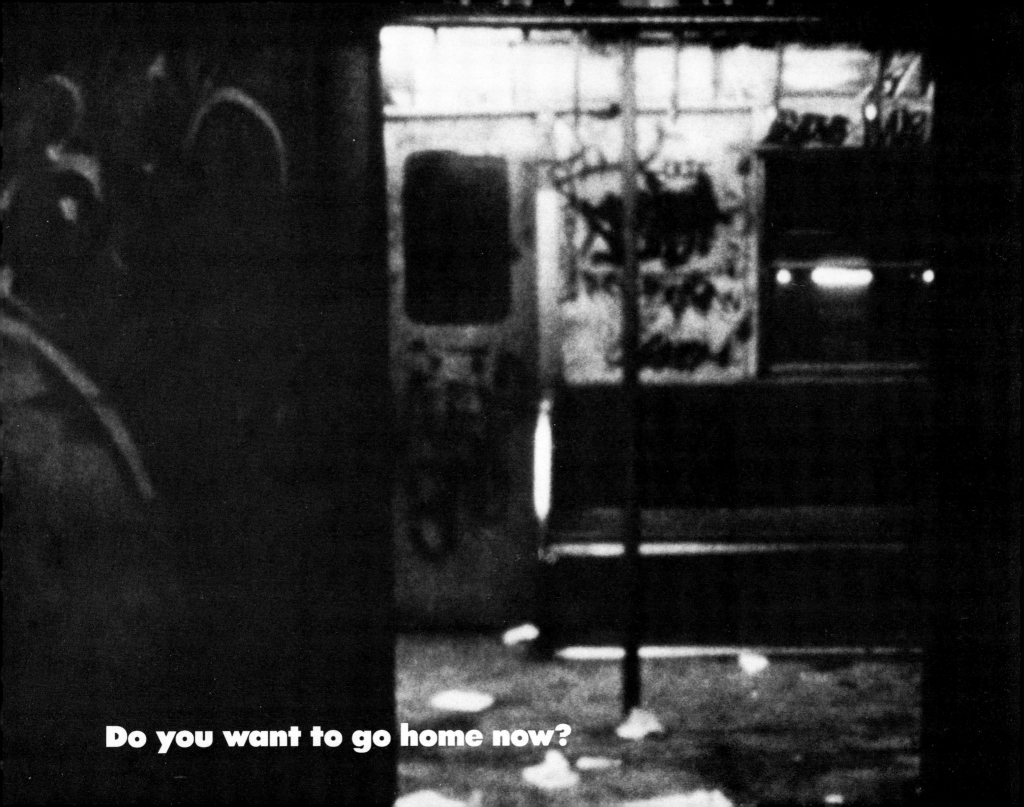

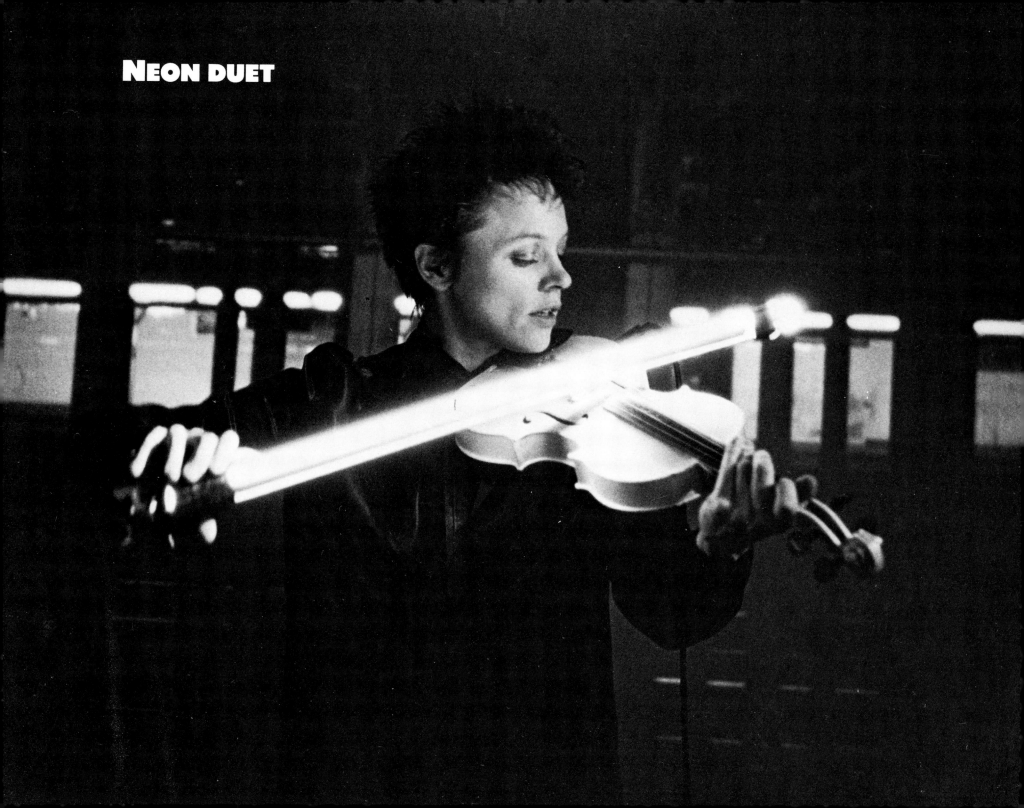

NEON DUET

LET X = X

$$7,584,931,556,734 \overline{)7,584,931,556,734}$$

I met this guy — and he looked like he might have been a hat check clerk at an ice rink — —
which, in fact, he turned out to be —
And I said: Oh boy! Right again!

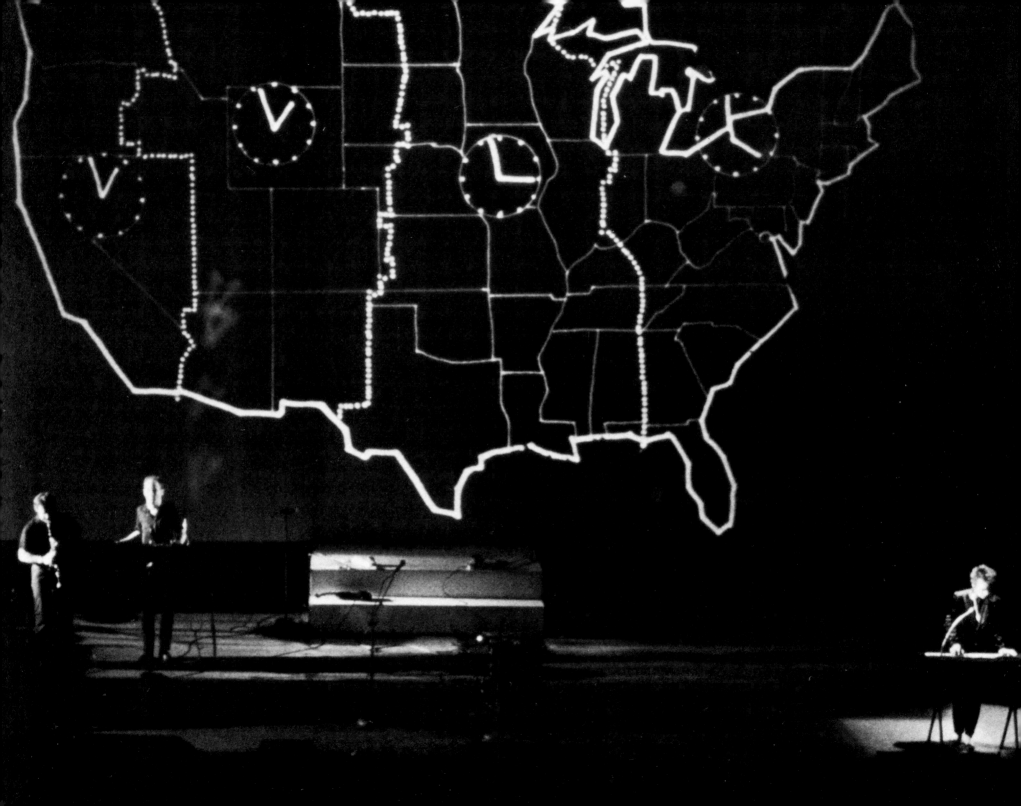

let x=x.
you know, it could be you.
It's a sky-blue sky.
Satellites are out tonight.
let x=x.

you know, I could write a book - And this book would be
thick enough to stun an ox.
Cause I can see the future -- and it's a place...
about 70 miles east of here - where it's lighter.
linger on over here.
Got the time?
let x = x.

POST CARD

I got this postcard and it read, it said: Dear Amigo... Dear Pardner --
Listen - I just want to say thanks. So... thanks.
Thanks for all the presents.
Thanks for introducing me to the Chief.
Thanks for putting on the feedbag. Thanks for going all out -
Thanks for showing me your Swiss Army knife.
Oh and uh... thanks for letting me autograph your cast.
Hug + kisses —
X X X O O O O

Oh yeah. P.S.
I... I feel - feel like - I am - in a burning building -
And I gotta go.
Cause I - I feel - feel like - I'm in a burning building -
and I gotta go.

It's a sky-blue sky.
Satellites are out tonight.
Let x=x.
You know, I could write a book.
Cause I can see the future -and it's a place
 about 70 miles west of HERE - where it's darker
Linger on over here.
Got the time?

Your eyes. It's a day's work looking into them.
Your EYES. It's a day's work just looking into them.

THE MAILMAN'S NIGHTMARE

I have this recurring nightmare, and that
is that everyone in the world, except my-
self, has the problems of babies.
I mean they're normal height and every-
thing—five feet, six feet tall—but they
have these giant heads,
like babies, you know? And enormous
eyes, and tiny arms and legs, and they
can hardly walk.
And I'm going down the street and when
I see them coming, I give them some
room and step aside.
Also, they don't read or write, so I don't
have that much to do.
Jobwise,
it's pretty easy.

DIFFICULT LISTENING HOUR

Good evening. Welcome to Difficult Listening Hour.
The spot on your dial for that relentless and
impenetrable sound of Difficult Music Music
So sit bolt upright in that straight-backed chair, Music
button that top button, Music
and get set for some difficult music:
Ooola. I came home today, and I opened
 the door with my bare hands,
Ooola and I said: Hey! Who tore up all my wallpaper
 samples? Who ate all the grapes—
Ooola the ones I was saving? And this guy was sitting
 there, and I said: Hey, Pal! What's
Ooola going on here? And he had this smile, and
 when he smiled he had these big white teeth,

Ooola like luxury hotels on the Florida coastline. And
 when he closed his mouth, it looked
Ooola like a big scar. And I said to myself: Holy
 smokes! Looks like some kind of a guest/
Ooola host relationship to me. And I said: Hey, pal!
 What's going on here anyway, who are you?
Ooola And he said: Now, I'm the Soul Doctor, and you
 know, language is a virus from Outer Space.

And hearing your name
is better than
seeing your face.

LANGUAGE IS A VIRUS

FROM OUTER SPACE.

—WILLIAM S. BURROUGHS

I saw this guy on the train, and he seemed to have gotten stuck in one of those abstract trances, and he was going ugh . . . ugh . . . ugh . . . And Geraldine said: You know, I think he's in some kind of *pain* . . . I think it's a pain cry. And I said: If that's a pain cry, then language . . . is a virus . . . from outer space. . . .

Well I was feeling really rotten the other day, I was feeling washed up . . . and I said to myself: I know what I'm going to do—I'm going to take myself out. So I went to the park and I sat down and I said: Boy is this fun. I'm really having fun now. I can't remember having this much fun before. . . . And then this little *dog* ran up, and this dog had ears like a drop-leaf table, and I said: Boy is this ever fun. . . .

M 16 N YC O TYPE P COAT Q TIP RS VP T SHIRT U BOAT V SIGN W WII X RAY Y ME?

Well I was talking to a friend the other day, and I was saying: I wanted you . . . and I was looking for you . . . but I couldn't find you. And he said: *Hey* . . . are you talking to me . . . or are you just practicing for one of those performances of yours?

ZZZZZZZZZZ

You know, I don't believe there's such a thing as the Japanese language. I mean, they don't even know how to write. They just draw pictures of these little characters, and when they talk, they just make sounds that more or less synch up with their lips. That's what I think. . . .

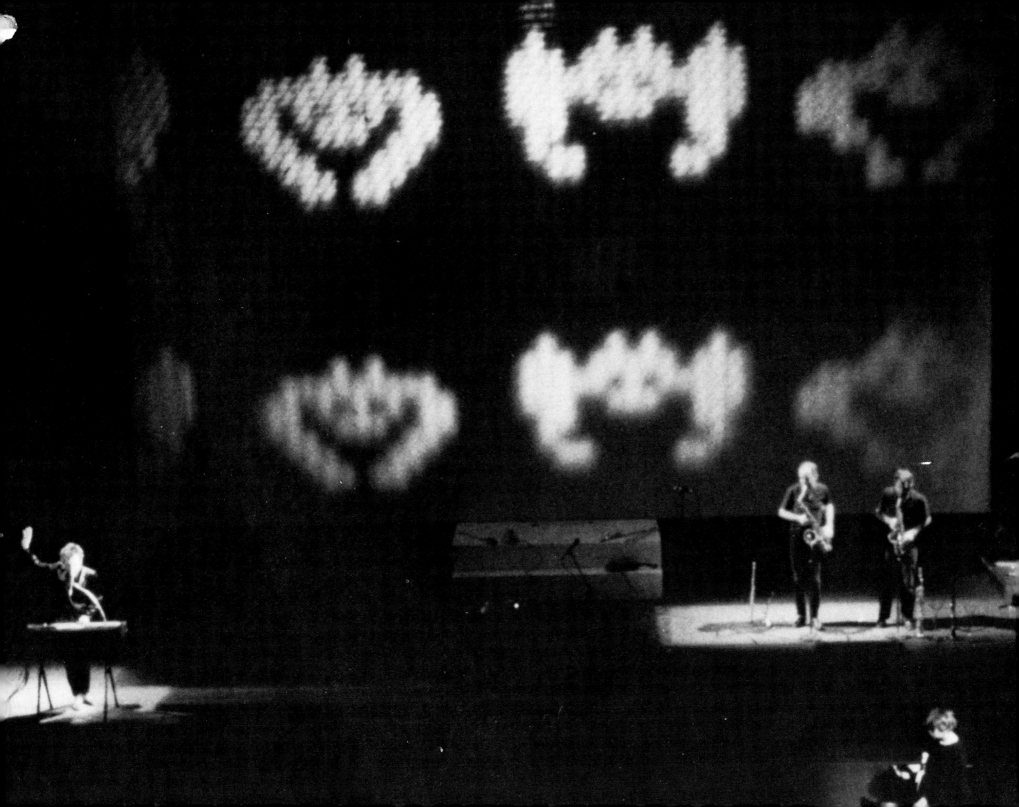

Well I walked uptown and I saw a sign that said: Today's lecture Big Science and Little Men. So I walked in and there were all these salesmen and a big pile of electronics. And they were singing: Phase Lock Loop. Neurological Bonding. Video Disc. They were singing: We're gonna link you up. They were saying: We're gonna phase you in. They said: Let's look at it this way—Picture a Christmas tree with lots of little sparkly lights, and each light is totally separate, but they're all sort of hanging off the same wire. Get the picture? And I said: Count me out. And they said: We've got your number. And I said: Count me out. You gotta count me out.

TO AMPLIFIER

CONTACT MICROPHONE

1 2

CONTACT MIC ATTACHED TO GLASSES - PRESSES ON HEAD; BANGING IS AMPLIFIED & REVERBED

If You Can't Talk About It, Point to It
(for Ludwig Wittgenstein and Reverend Ike)

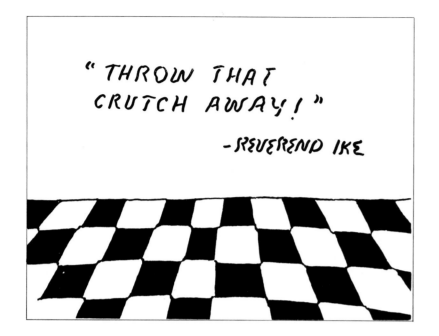

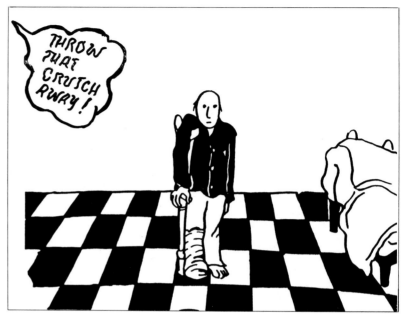

There are ten million stories in the Naked City.

But no one can remember which one is theirs.

FINNISH FARMERS

During WWII, the Russians were testing their parachutes. Sometimes they didn't open at all and a lot of troops were lost this way. During the invasion of Finland, hundreds of troops were dropped during the middle of winter. As usual, some of the chutes didn't open and the troops fell straight down into the deep snow, drilling holes fifteen feet deep. The Finnish farmers would then get out their shotguns, walk out into their fields, find the holes, and fire down them.

During the 1979 drought in the Midwest, the American farmers began to rent their property to the United States government as sites for missile silos. They were told: Some of the silos contain Minutemen, and some do not. Some are designed to look like ordinary corn and grain silos. The military called these the Decoy Silos, but the farmers called them the Scarecrows. The government also hinted that some of these silos might be connected by hundreds of miles of railroad in an underground shuttle system.

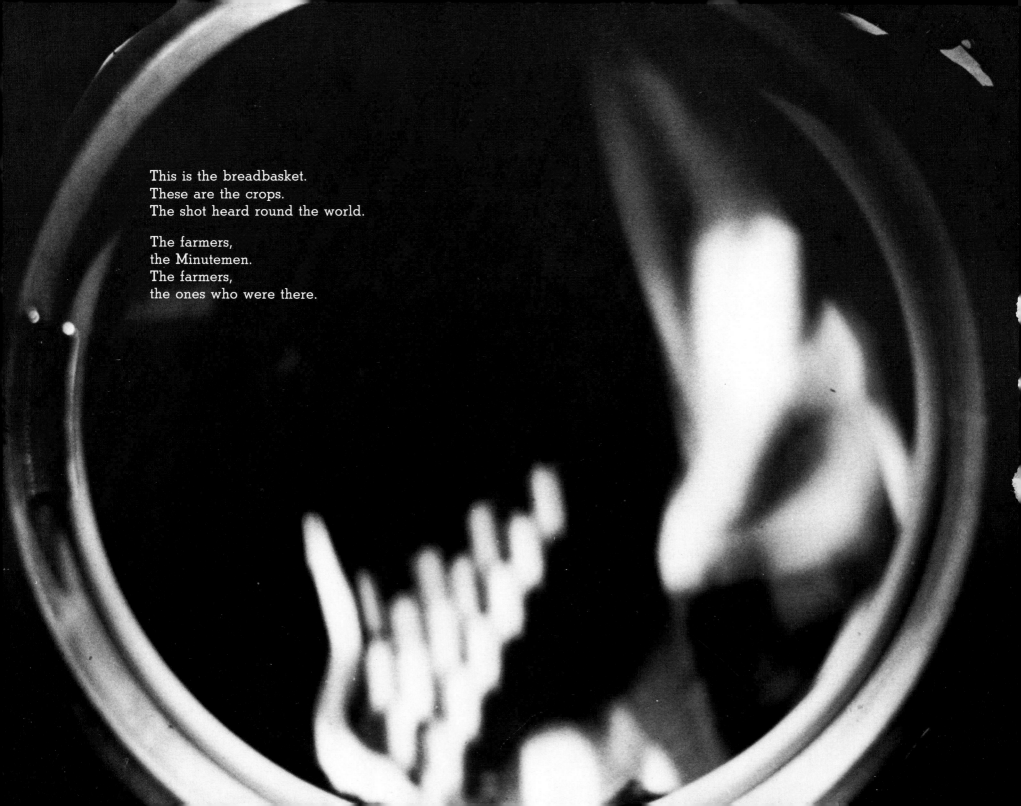

This is the breadbasket.
These are the crops.
The shot heard round the world.

The farmers,
the Minutemen.
The farmers,
the ones who were there.

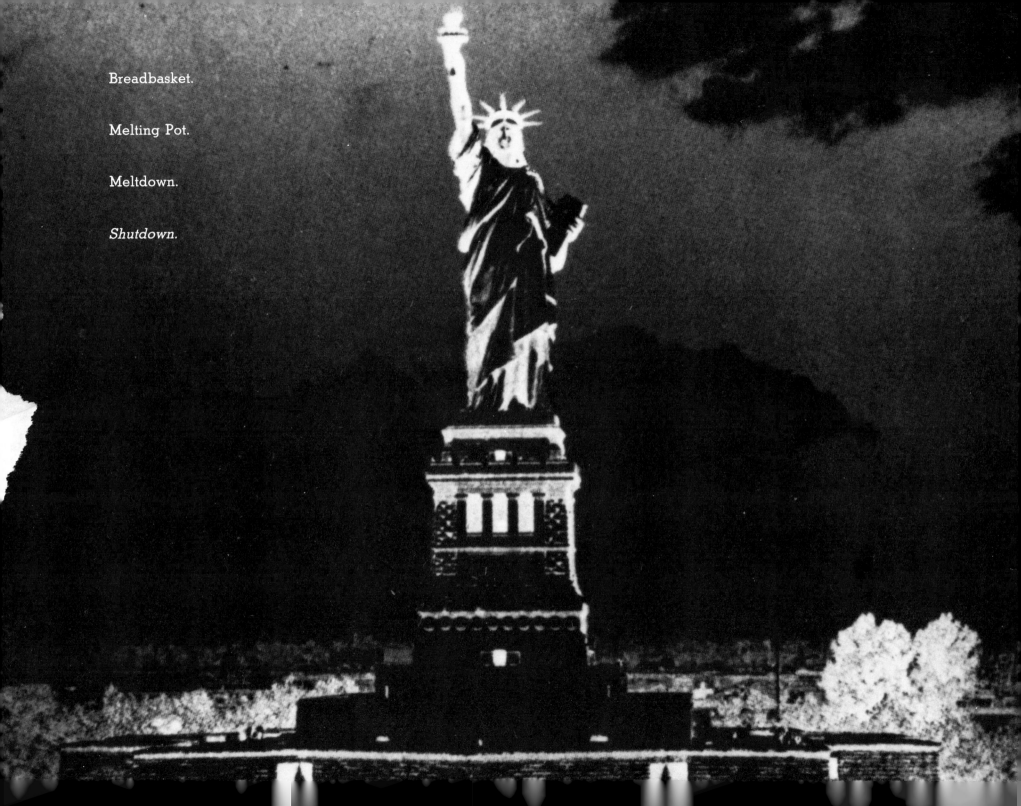

Breadbasket.

Melting Pot.

Meltdown.

Shutdown.

PART THREE

It was up in Canada and it was August, but very cold. I had been staying on this Cree Indian reservation for a few days, just sort of hanging around. One day, some anthropologists showed up at the reservation. They came in a little plane with maple leaves painted on the wings. They said they were there to shoot a documentary of the Cree Indians. They set up their video equipment in a tin Quonset hut next to the Hudson Bay Company. Then they asked the oldest man on the reservation to come and sing some songs for their documentary. On the day of the taping, the old man arrived. He was blind and wearing a red plaid shirt. They turned on some lights and he started to sing. But he kept starting over and sweating. Pretty soon it was clear that he didn't really know any of the songs. He just kept starting over and sweating and rocking back and forth. The only words he really seemed sure of were "*Hey ah* . . . hey ah hey . . . hey hey hey ah hey . . . hey . . ."

Hey ah hey hey hey ah hey
I am singing the songs,
Hey ah hey ah hey
the old songs . . . but I can't remember the words of the
songs,
Hey hey hey ah hey
the old hunting songs.
I am singing the songs of my fathers and of the animals
they hunted down.
Hey hey hey ah hey
I never knew the words of the old songs.
Hey hey ah hey hey hey hey ah hey
I never went hunting.
Hey hey ah ah hey ah hey
I never sang the songs
Hey ah hey
of my fathers.
Hey hey ah hey
I am singing for this movie;
Hey ah
I am doing this for money.
Hey hey ah hey
I remember Grandfather;
he lay on his back while he was dying.
Hey ah hey hey ah hey
I think I am no one.
Hey hey ah hey hey

BAGPIPE SOLO

REDSKINS
RED COATS
RED TAPE
RED INK
RED LETTER
RED HANDED
RED BLOODED
RED EYE
RED NECK
RED WOOD
RED BAIT
RED HERRING
RED CROSS

THE REDS

ST[E]VEN W[EE]D

Steven Weed — was asked
by the FBI — to come in
and answer a few questions. — He said it wasn't
like an interrogation room — at all.
There were no — bright lights.
But he said — they had it set up
so that there was an agent — on his right
and an agent on his left — and that they alternated
questions so that he had — to keep turning
his head in order — to answer them.
And he said after a few hours — of doing this
that no matter — what question they asked
or what answer he gave — the answer always
looked — like
no — no
oh-no. — no.

TIME AND A HALF

In the middle of the seventeenth century, the only people living in the American colonies were the Indians, a few scattered pilgrims, and lots of British troops. Communication between Britain and the colonies was confused and chaotic. King George told the troops: "Just pick some kind of headquarters and talk to me from there. I don't care where you put it."

The logical choice for the headquarters was Philadelphia which had a few brick streets and some picturesque supply stores and nobody has ever been able to figure out why the British troops chose Washington instead—which was basically a few shacks in a swamp.

Recently, historians have discovered two facts that might add up to a possible explanation. First, the outskirts of Washington, D.C. lay just a few yards inside the official subtropical zone of the British Empire. Second, all British troops working in subtropical zones were paid time and a half.

VOICES ON TAPE

Was ist das Prinzip?
What is the principle?
Das Prinzip ist folgenes:
The principle is as follows:
Klang besteht aus Wellen.
Sound is composed of waves.
Wenn die Wellen sich zu Formen beginnen, horen wir das als Klang.
When the wave form begins, we hear it as sound.
Sie sind nicht mehr hörbar, sie bewegen sich langsamer.
But long after the sound has disappeared, the waves continue to travel.
Dies ist ein normaler Raum.
This is a normal room.
Niemand hat ihn seit 1955 betreten.
No one has been in this room since 1955.
Aber er ist immer noch voller langsam sich bewegen der Wellen. Die Stimmen und Klange längst
verflossener jahre darstellen.
However, it is still full of slowly traveling waves. The original sound and voices continue
to move back and forth.
Mit starken Stereo-mikrofonen, war es uns moglich diese Klange aufzunehman, und sie in horbare Satze urzuwandeln.
With sensitive stereo microphones, we were able to record these waves,
and then translate them back into their original form:
words.

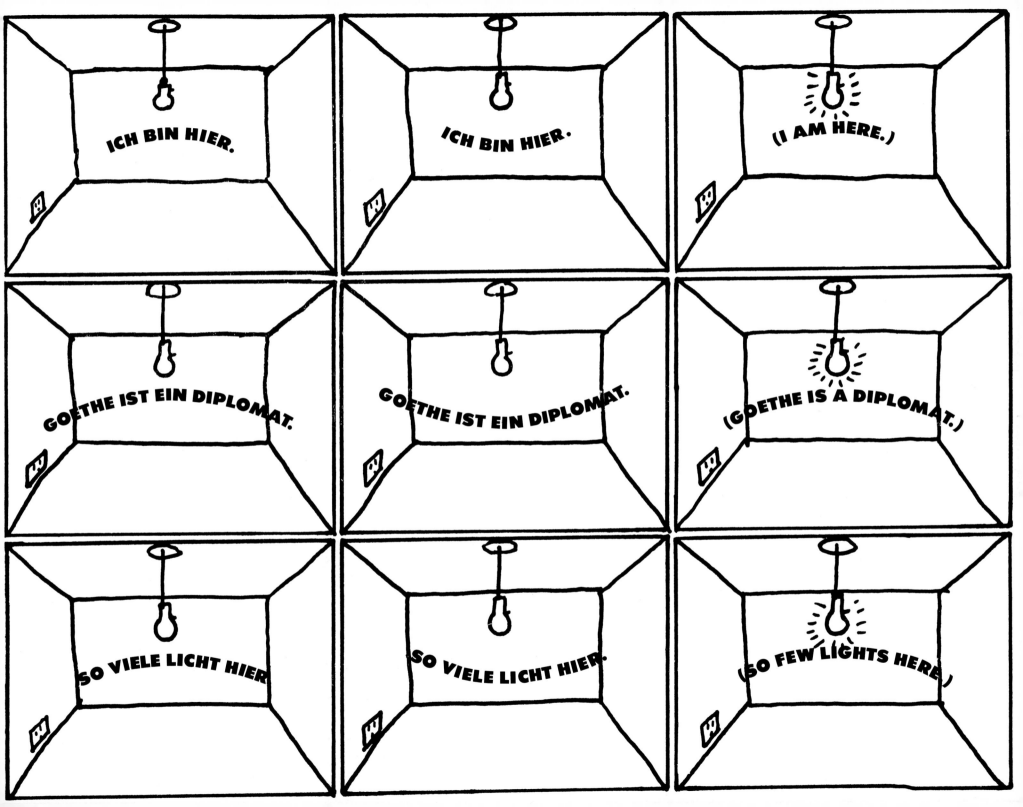

EXAMPLE #22

The sun is shining slowly.
The birds are flying so low.
Honey, you're my one and only.
So pay me what you owe me.

Lights are going down slowly.
In the woods, the animals are moving.
Honey, you're my one and only.
So pay me what you owe me.

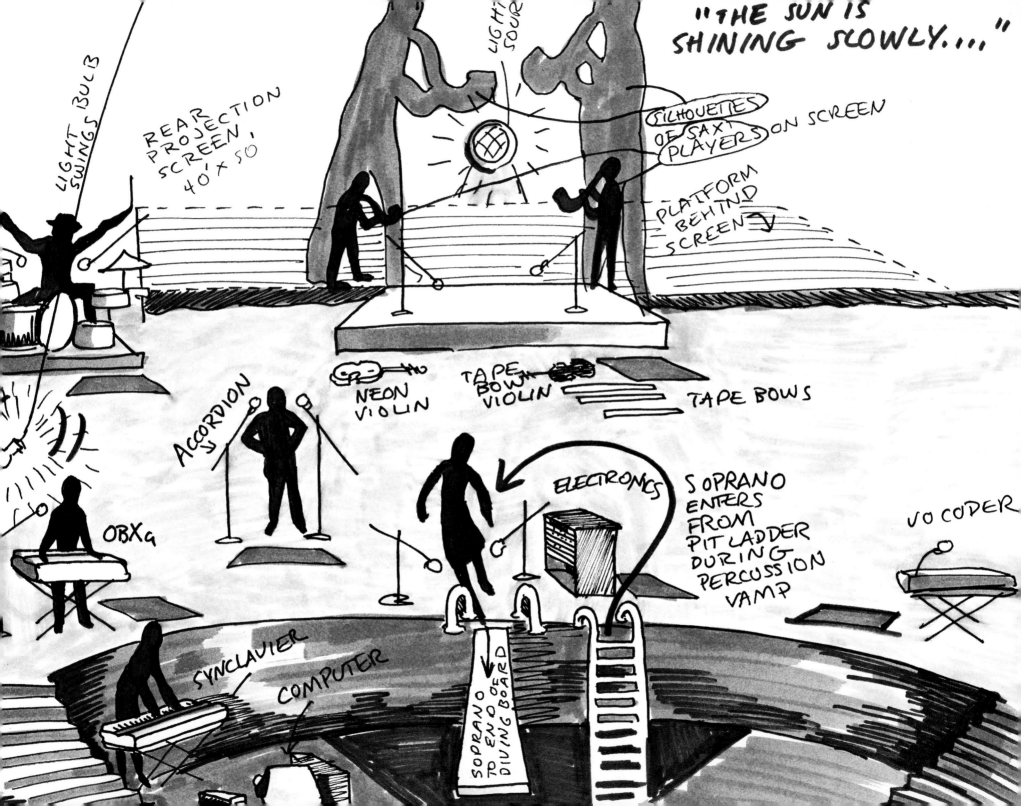

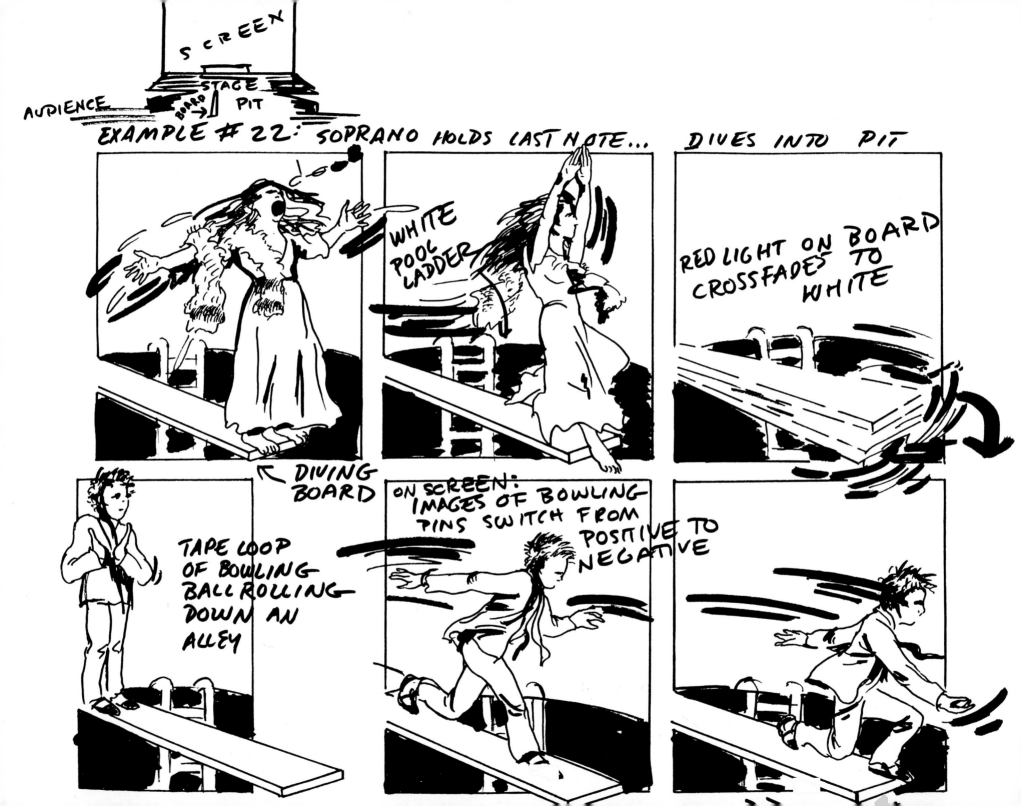

STRIKE

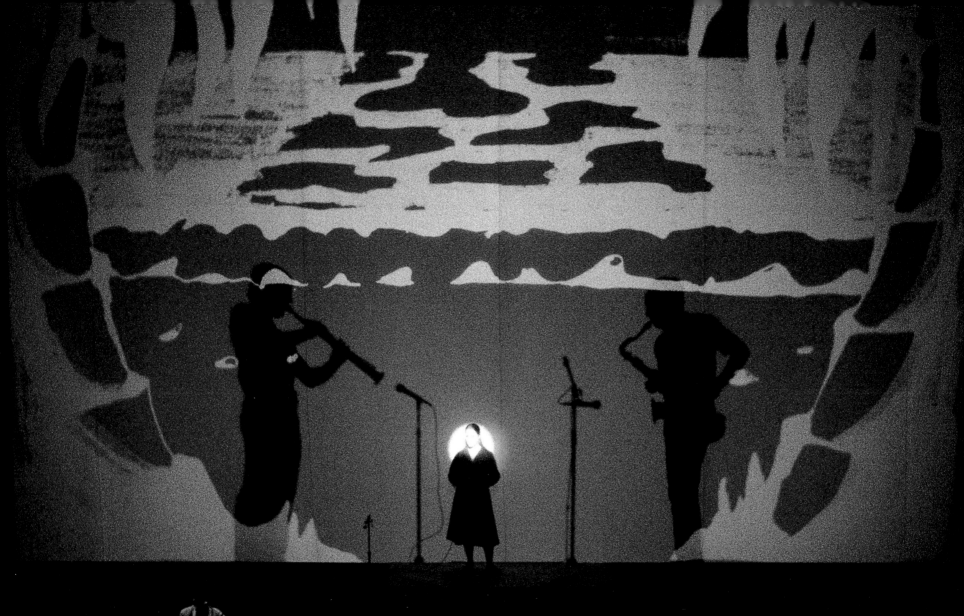

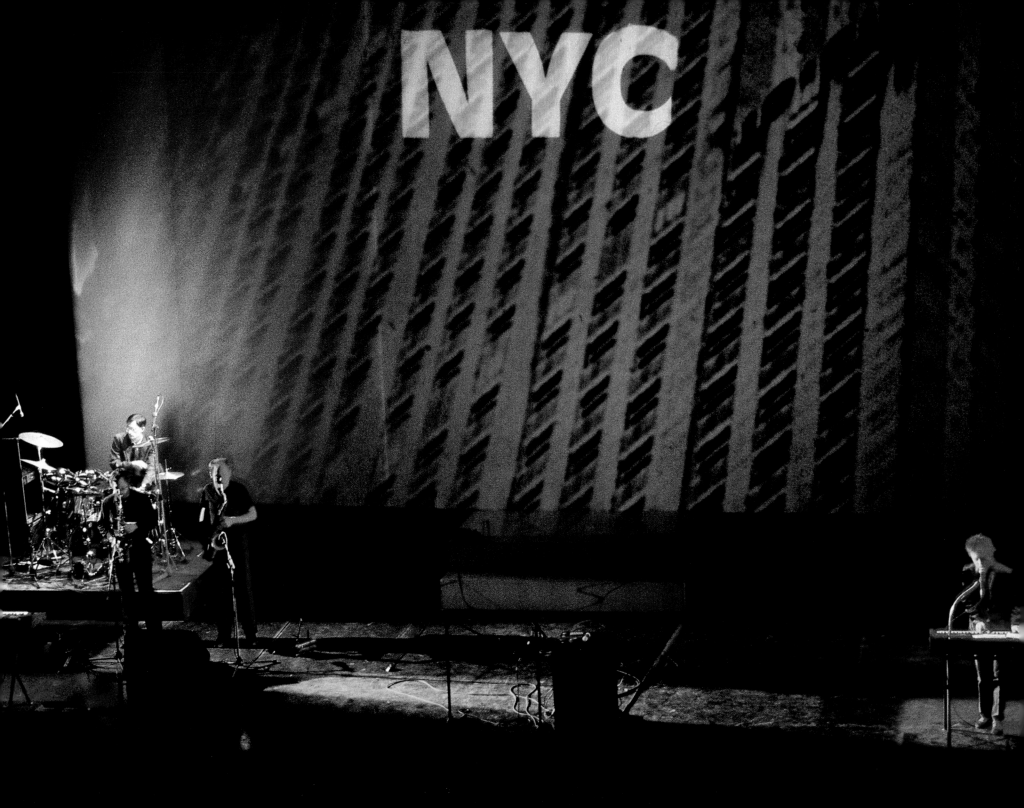

I AM A SINCERE, DYNAMIC, PROF BLACK
MAN 32, WHO'S LKNG TO SHR GD FOOD, GD
WINE AND GD COMPANY. AGE 35+ RACE
UNIMPORTANT. VVM17605

I'D LIKE TO MARRY A MAN WHO PLAYS
THE VIOLIN REALLY WELL, LOVES T
DANCE, IS IN HIS 40s & DOESN'T
TALK TOO MUCH. VV M-16510

(SO FEW LIGHTS HERE.)

BORN, NEVER ASKED

JOIN, or DIE

FALSE DOCUMENTS

I went to a palm reader and the odd thing about the reading
was that everything she told me was totally wrong. She said
I loved airplanes, that I had been born in Seattle, that my
mother's name was Hilary. But she seemed so sure of the
information that I began to feel like I'd been walking
around with these false documents permanently tattooed to
my hands. It was very noisy in the parlor and members of
her family kept running in and out. They were speaking a
high, clicking kind of language that sounded a lot like
Arabic. Books and magazines in Arabic were strewn all
over the floor. It suddenly occurred to me that maybe there
was a translation problem—that maybe she was reading my
hand from right to left instead of left to right.

Thinking of mirrors, I gave her my other hand. Then she
put her other hand out and we sat there for several minutes
in what I assumed was some kind of participatory ritual.
Finally I realized that her hand was out because she was
waiting for money.

NEW YORK SOCIAL LIFE

Well I was lying in bed one morning, trying to think of a good reason to get up, and the phone rang and it was Geri and she said: Hey, hi! How are you? What's going on? How's your work?

Oh fine. You know, just waking up but it's fine, it's going OK, how's yours?
Oh a lot of work, you know, I mean, I'm trying to make some money too. Listen, I gotta get back to it, I just thought I'd call to see how you are . . .

And I said: Yeah, we should really get together next week. You know, have lunch, and talk. And she says: Yeah, uh, I'll be in touch. OK?

OK.
Uh, listen, take care.

OK. Take it easy.
Bye bye.

Bye now. And I get up, and the phone rings and it's a man from Cleveland and he says: Hey, hi! How are you? Listen, I'm doing a performance series and I'd like you to do something in it. Uh, you know, you could make a little money. I mean, I don't know how I *feel* about your work, you know, it's not really my style, it's kind of trite, but listen, it's *just* my opinion, don't take it personally. So listen, I'll be in town next week. I gotta go now, but I'll give you a call, and we'll have lunch, and we can discuss a few things.

And I hang up and it rings again and I don't answer it and I go out for a walk and I drop in at the gallery and they say: Hey, hi. How are you?

Oh fine. You know.
How's your work going?

OK. I mean . . .

You know, it's not like it was in the sixties. I mean, those were the days, there's just no money around now, you know, survive, produce, stick it out, it's a jungle out there, just gotta keep working.
And the phone rings and she says: Oh excuse me, will you? Hey, hi! How are you? Uh huh. How's your work? *Good.* Well, listen, stick it out, I mean, it's not the sixties, you know, listen, I gotta go now, but, uh, lunch would be great.

Fine, next week? Yeah. Very busy now, but next week would be fine, OK? Bye bye.

Bye now.

And I go over to Magoo's, for a bite, and I see Frank and I go over to his table and I say:

Hey Frank. Hi, how are you? How's your work? Yeah, mine's OK too. Listen, I'm broke you know, but, uh, working . . . Listen, I gotta go now, uh, we should *really* get together, you know. Why don't you drop by sometime? Yeah, that would be great. OK. Take care.

Take it easy.

I'll see you.

I'll call you.

Bye now.

Bye bye.

And I go to a party and everyone's sitting around wearing these party hats and it's really awkward and no one can think of anything to say. So we all move around—fast—and it's: Hi! How are you? Where've you been? Nice to see you. Listen, I'm sorry I missed your thing last week, but we should really get together, you know, maybe next week. I'll call you. I'll see you.

Bye bye.

And I go home and the phone rings and it's Alan and he says: You know, I'm gonna have a show on, uh, cable TV and it's gonna be about loneliness, you know, people in the city who for whatever sociological, psychological, philosophical reasons just can't seem to communicate, you know, The Gap, The Gap, uh, it'll be a talk show and people'll phone in but we will say at the beginning of each program: Uh, listen, don't call in with your *personal* problems because we don't want to hear them.

And I'm going to sleep and it rings again and it's Mary and she says:

Hey, Laurie, how are you? Listen, uh, I just called to say hi . . . Uh, yeah, well don't worry. Uh, listen, just keep working. I gotta go now. I know it's late but we should really get together next week maybe and have lunch and talk and . . . Listen, Laurie, uh, if you want to talk before then, uh, I'll leave my answering machine on . . . and just give me a ring . . . anytime.

A CURIOUS PHENOMENON

Recently there has been a discovery of a curious phenomenon deep in the deciduous woods of Southern Illinois. In the midst of the underbrush there is a clearing revealing a circle of short wooden tree-stump-like structures. In the middle of that circle there is a post-and-lintel structure. The entire circular configuration is oriented toward the exact point at which the sun rises on the day of the summer solstice.

Who built this structure? And for what purpose? To what end? A primitive calendar? A center of worship? A lost tribe?

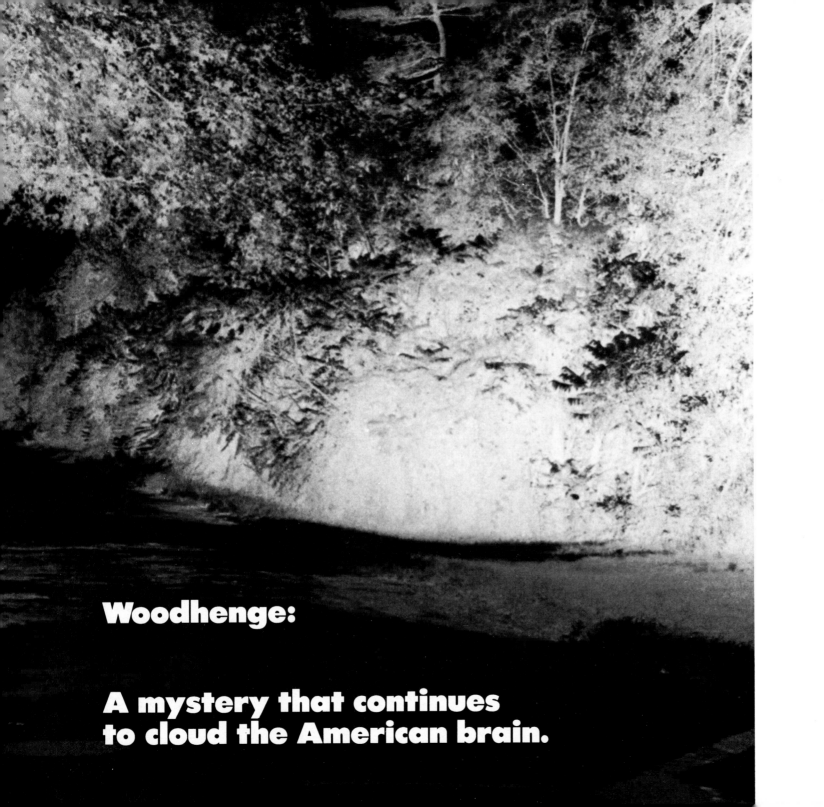

Woodhenge:

**A mystery that continues
to cloud the American brain.**

YANKEE SEE

Well I had a dream and in it I was teaching cave people how to use blenders and toasters. I drive up to the cave in my car. Hey hey hey hey hey hey hey. In my car.

And there they are banging their heads against the walls of the cave. And I say: Hey folks! Listen, you're doing it the hard way. Lemme show you a thing or two. One. Two. Three. Four.

Well I was trying to think of something to tell you about myself, and I came across this brochure they're handing out in the lobby. And it says everything I wanted to say—only better.

It says: Laurie Anderson, in her epic performance of United States Parts 1 through 4, has been baffling audiences for years with her special blend of music . . . slides . . . films . . . tapes . . . films (did I say films?) . . . hand gestures and more. Hey hey hey hey hey hey hey! (Much more.)

Let's take a look around the stage at what we like to call
The System—i.e., the highly sophisticated (very expensive)
state-of-the-art gadgetry with which I cast my spell.

Now let me tell you something: this stuff does not grow
on trees.

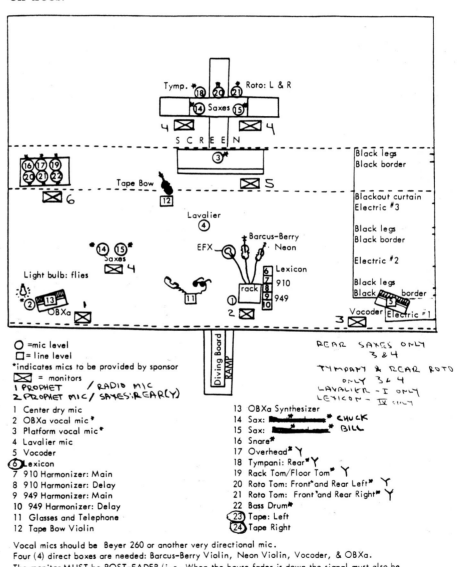

○ = mic level
□ = line level
*indicates mics to be provided by sponsor
⊠ = monitors
1 PROPHET / RADIO MIC
2 PROPHET MIC / SAXES: REAR(Y)

1 Center dry mic
2 OBXa vocal mic*
3 Platform vocal mic*
4 Lavalier mic
5 Vocoder
⑥ Lexicon
7 910 Harmonizer: Main
8 910 Harmonizer: Delay
9 949 Harmonizer: Main
10 949 Harmonizer: Delay
11 Glasses and Telephone
12 Tape Bow Violin

13 OBXa Synthesizer
14 Sax: ▬▬▬▬▬* CHUCK
15 Sax: ▬▬▬▬* BILL
16 Snare*
17 Overhead* Y
18 Tympani: Rear* Y
19 Rack Tom/Floor Tom* Y
20 Roto Tom: Front* and Rear Left* Y
21 Roto Tom: Front *and Rear Right* Y
22 Bass Drum*
㉓ Tape: Left
㉔ Tape Right

REAR SAXES ONLY
3 & 4
TYMPANY & REAR ROTO
ONLY 3 & 4
LAVALIER - I ONLY
LEXICON - IV ONLY

Vocal mics should be Beyer 260 or another very directional mic.
Four (4) direct boxes are needed: Barcus-Berry Violin, Neon Violin, Vocoder, & OBXa.
The monitor MUST be POST-FADER (i.e. When the house fader is down the signal must also be
 completely out of the monitors) for: Lexicon, Tape (L & R), Harmonizer lines (at least Main
 lines, preferably Delay lines, too.).

Well I was out in L.A. recently on music business, and I was just sitting there in the office filling them in on some of my goals.

And I said: Listen, I've got a vision. I see myself as part of a long tradition of American humor. You know—Bugs Bunny, Daffy Duck, Porky Pig, Elmer Fudd, Roadrunner, Yosemite Sam.

And they said: "Well actually, we had something a little more adult in mind."

And I said: "OK! OK! Listen, I can adapt!"

Lucy I'm home. Lucy, I'm home!
LUCY? I'm home!!
I wonder what happened to her?

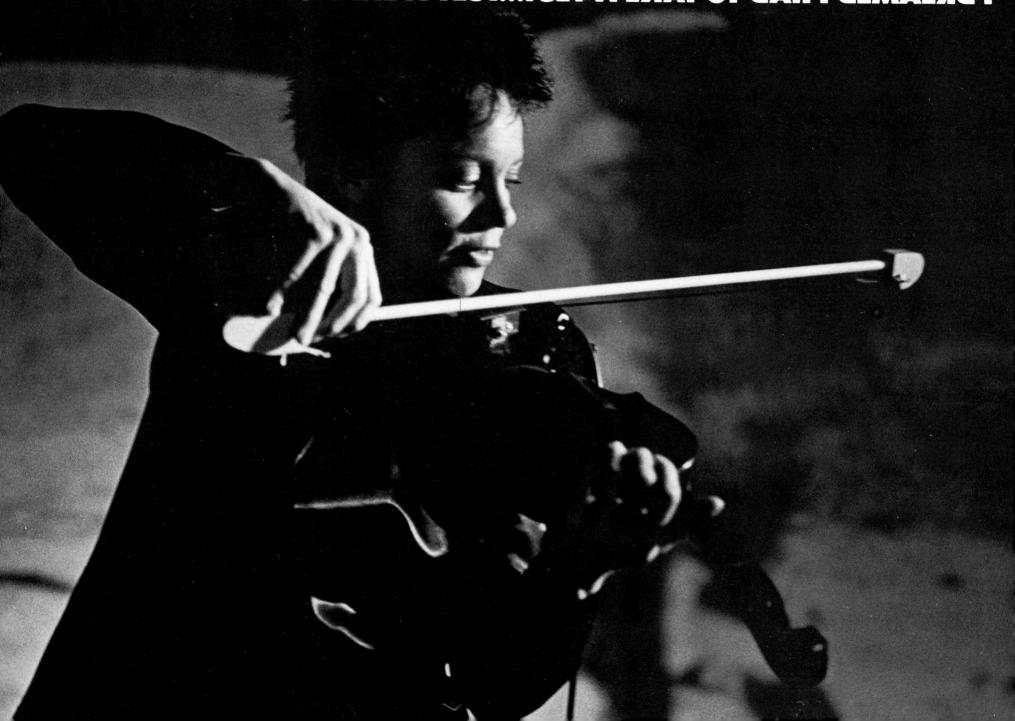

I DREAMED I HAD TO TAKE A TEST...

FOUR, THREE, TWO, ONE

Four three two one. Rock the cradle.
Rule the world.
One two three four. Beat the clock.
Stop the press.

Four three two one. Stop the press.
Beat the clock. Rock the cradle. And
rule the world.

THE BIG TOP

When Buckminster Fuller came to Canada, he kept
asking the same question:
"Have you ever really considered how much your
buildings weigh?"
The Canadians took this very seriously. (Hey, we never
thought of that!)
He showed them plans for domed cities,
cities with no basements,
no foundations.
Cities that could be moved in a minute.
Portable cities.
Portable towns.

He said:
Think of it as
camping out.
Think of it as
one big tent.
He said:
Think of it as
The Big Top . . . spinning . . . lightweight . . . portable.

He said: Think of it as
The Big Top.
Spinning . . .
Lightweight . . .
Flyaway. . . .

He said:
Think of it as the
Big Top.

IT WAS UP IN THE MOUNTAINS

It was up in the mountains. We had this ceremony every
year. We had it and everyone from miles around came in
for it. Cousins, aunts, uncles, and the kids. Grandmothers,
grandfathers . . . everyone. And we set it up around this big
natural pool. With pine trees and palm trees. All the trees
were there. And we had thousands of those big urns—you
know the kind. And everyone would dance and sing, and
it lasted for three days. Everyone cooked and looked for-
ward to it all the year.

Well one year, we were in the middle of it, and I was just
a boy at the time. Anyway, it was evening, and suddenly a
whole lot of tigers came in. I don't know where they came
from. They rushed in, snarling, and knocked over all the
urns, and it was really a mess.

Well, we spent the whole next year rebuilding every-
thing. But in the middle of the ceremony the next time the
same thing happened. These tigers rushed in again and
broke everything and then went back into the mountains.
This must have gone on four or five years this way—re-
building and then the tigers would come and break every-
thing. We were getting used to it.

Finally we had a meeting and decided to make these
tigers part of the ceremony—you know—to expect them.
We began to put food in the urns, so the tigers would have
something to eat. Not much at first . . . crackers, things like
that. Then later we put more food until finally we were
saving our food all year for the tigers.
Then one year, the tigers didn't come. They never came
back.

ODD OBJECTS

Our plan is to drop a lot of odd objects onto your country from the air. And some of these objects will be useful. And some of them will just be odd.

Proving that these oddities were produced by a people free enough to think of making them in the first place. The U.S. helps, not harms, developing nations by using their natural resources and raw materials.

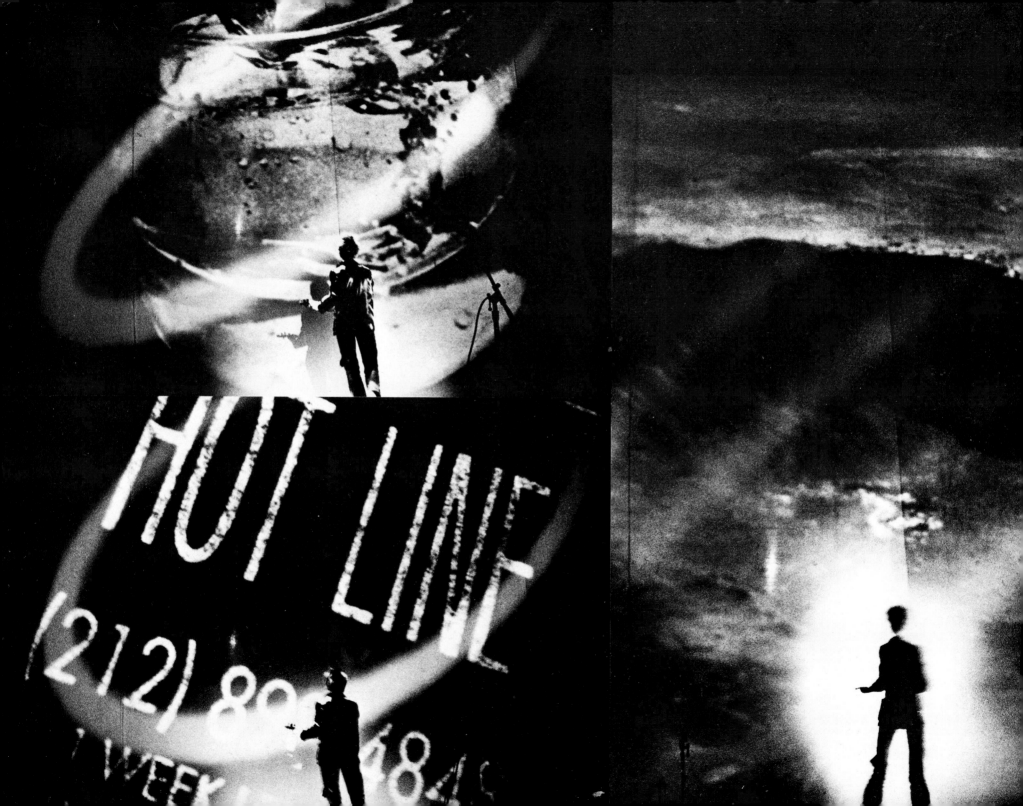

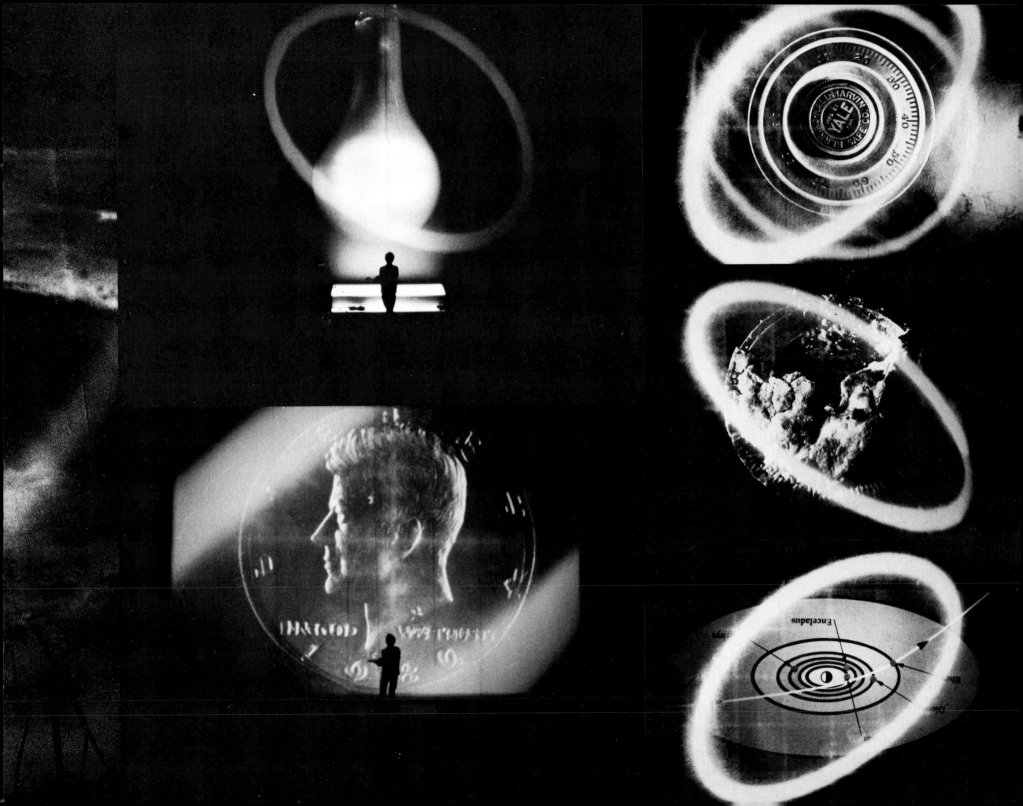

One of the reasons that Chrysler has run into such financial trouble is that there have been some problems with the relay devices between the computers and the robot welders. When a problem develops further up the line, it takes a long time for the computers to tell the robot welders to stop. So the robot welders continue to make these welding motions, dropping molten steel directly onto the conveyor belt, even though there are no cars on the line, building up a series of equidistant blobs. It takes several hours for the computers to tell the robot welders to stop. At the rate of eighty cars per hour, a typical plant is capable of manufacturing approximately 100 of these blobs before the plant can be totally shut down.

BIG SCIENCE

Coo coo coo it's cold outside. Coo
coo. It's cold outside. Don't forget
your mittens.

Hey! Pal! How do I get to town from
here?
And he said: Well, just take a right
where they're gonna build that new
shopping mall,
go straight past where they're gonna
put in the freeway,
take a left at what's gonna be the new
sports center,
and keep going until you hit the place
where they're thinking of
building that drive-in bank. You can't
miss it.
And I said: This must be the place.

Coo coo coo. Golden cities. Golden
towns.
Golden cities. Golden towns.
And long cars in long lines.
And great big signs. And they all say:
Hallelujah. Yodellayheehoo. Every
man for himself.
Ooo coo coo. Golden cities. Golden
towns. Thanks for the ride.

Big Science. Hallelujah. Big Science.
Yodellayheehoo.

You know, I think we should put some
mountains here. Otherwise, what are
the characters
going to fall off of? And what about
stairs? Yodellayheehoo.

Here's a man who lives a life of
danger. Everywhere he goes, he stays
a stranger. Howdy stranger.
Mind if I smoke?
And he said: Every man for himself.
Every man, every man for himself.
All in favor say aye.
Hey professor! Could you turn out the
lights? Let's roll the film!

Big Science. Hallelujah. Big Science.
Yodellayheehoo.

PART FOUR

IT TANGO

She said, It looks, don't you think
it looks a lot like rain?

He said, Isn't it, isn't it just
isn't it just like a woman?

She said, It goes. That's the way
it goes. It goes that way.

He said, Isn't it, isn't it just
like, just like a woman?

She said, It's hard. It's just hard.
It's just kind of hard to say.

He said, Isn't it just, just
like a woman?

She said, It takes. It takes one.
It takes one to. It takes one to know
one.

He said, Isn't it, isn't it
just like a woman?

She said, she said it,
she said it to know,
she said it to no one.

Isn't it, isn't it just,
Isn't it just like a woman?

BLUE LAGOON

I had this dream
and in it I wake up in this small
house. Somewhere in the tropics. And
it's very hot and humid
and all these names and faces are
somehow endlessly moving
through me.
It's not that I see them, exactly; I'm not
a person in this dream; I'm a
place. Yeah . . . just a place. And I
have no eyes,
no hands, and all these names and
faces keep . . .
they keep passing through. And
there's no
scale. Just a lot of details.
Just a slow
accumulation
of
details.

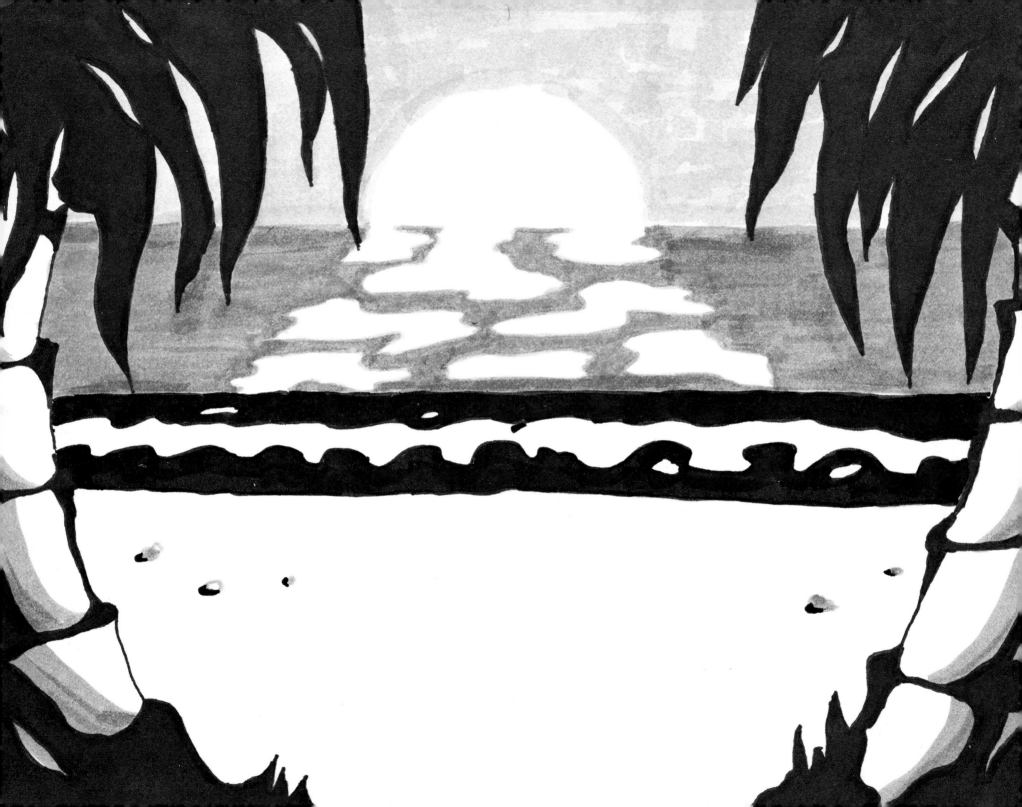

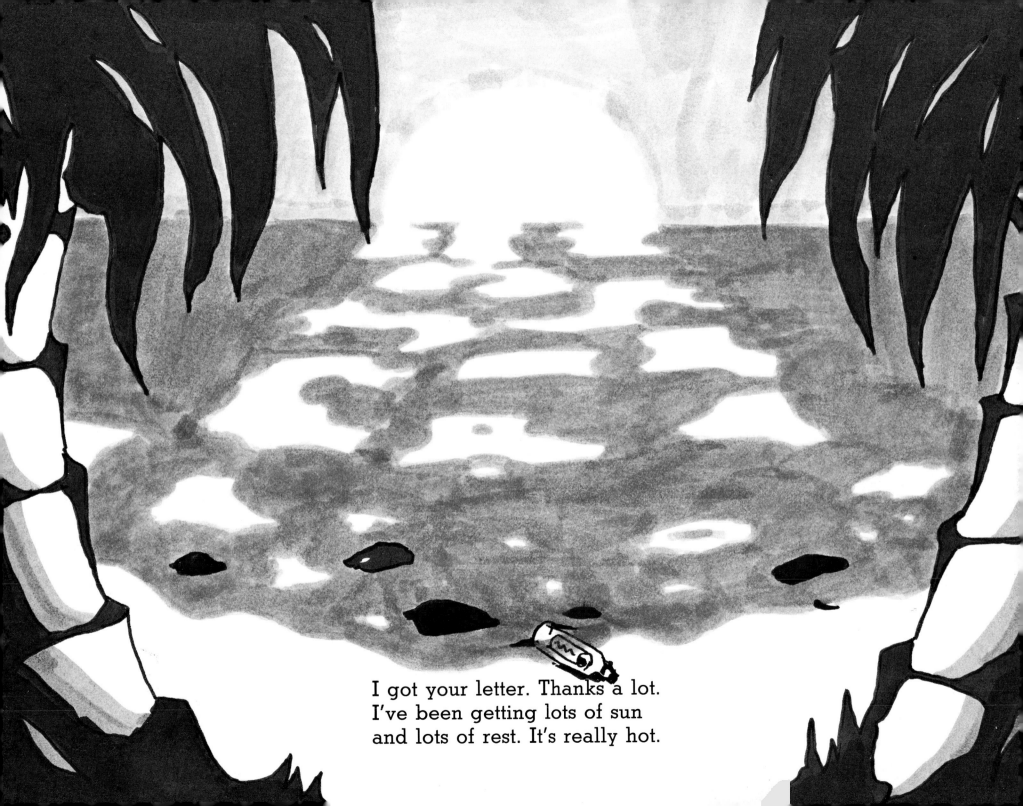

I got your letter. Thanks a lot.
I've been getting lots of sun
and lots of rest. It's really hot.

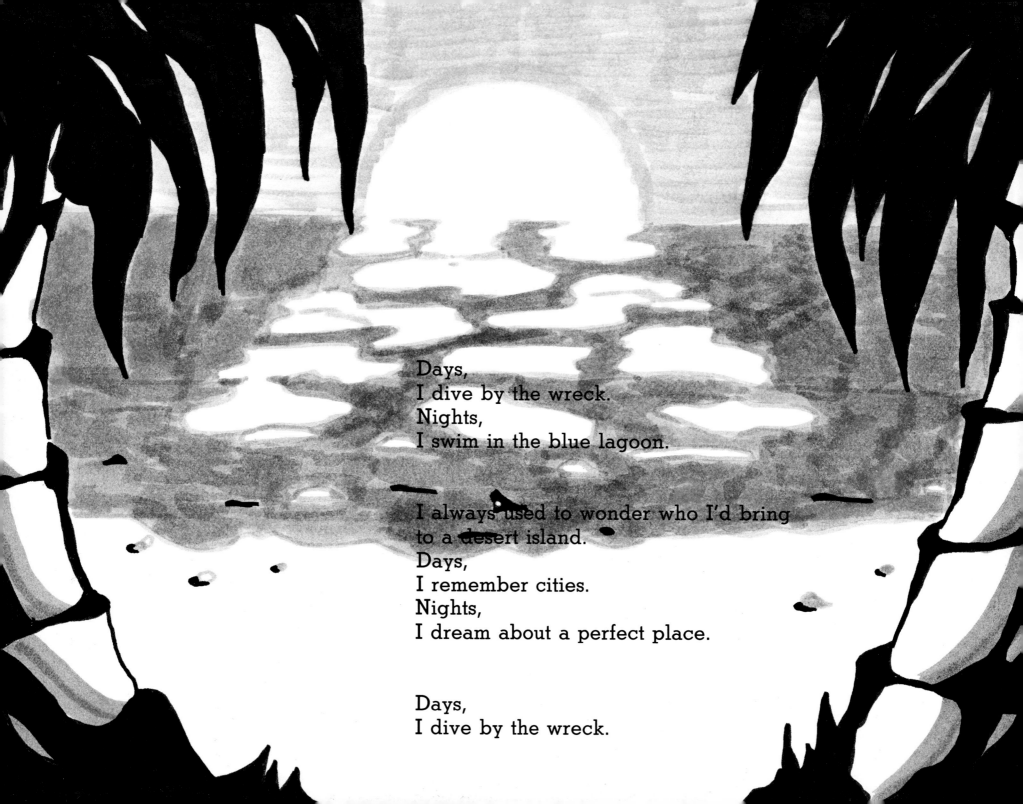

Days,
I dive by the wreck.
Nights,
I swim in the blue lagoon.

I always used to wonder who I'd bring
to a desert island.
Days,
I remember cities.
Nights,
I dream about a perfect place.

Days,
I dive by the wreck.

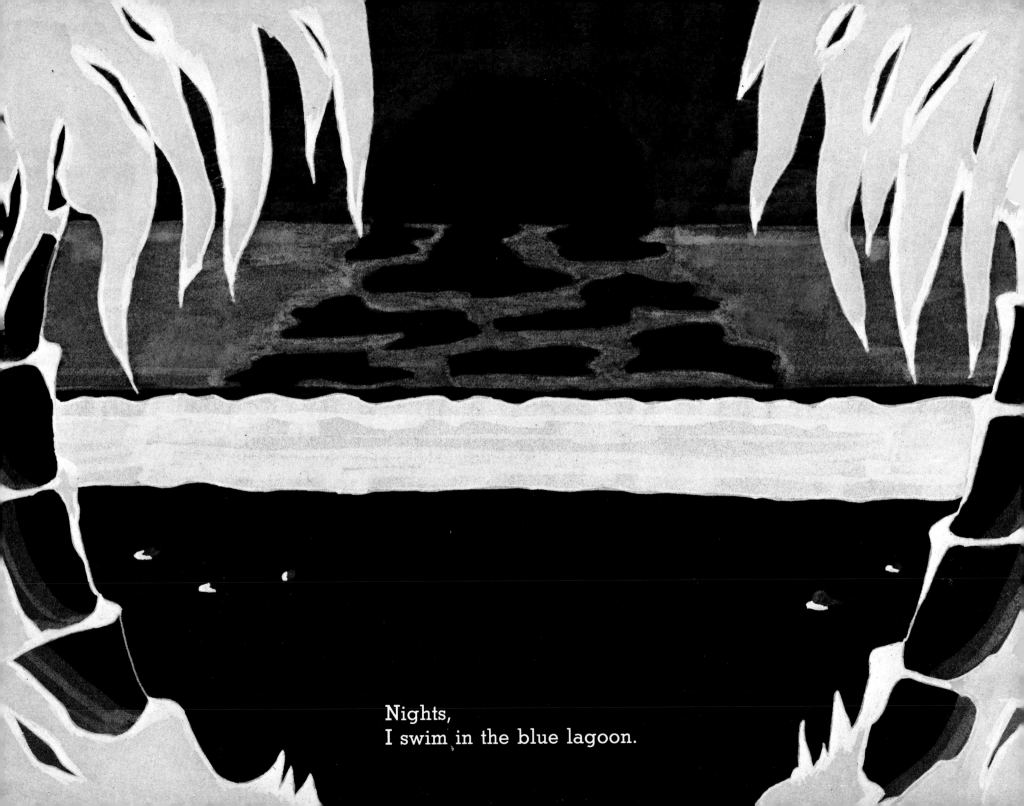

Nights,
I swim in the blue lagoon.

Full fathom five
thy father lies.
Of his bones
are coral made.
Those are pearls
that were his eyes.
Nothing about him fades.
But that suffers a sea change.
Into something rich
and strange.

And I alone am left to tell the tale . . .
Call me Ishmael.

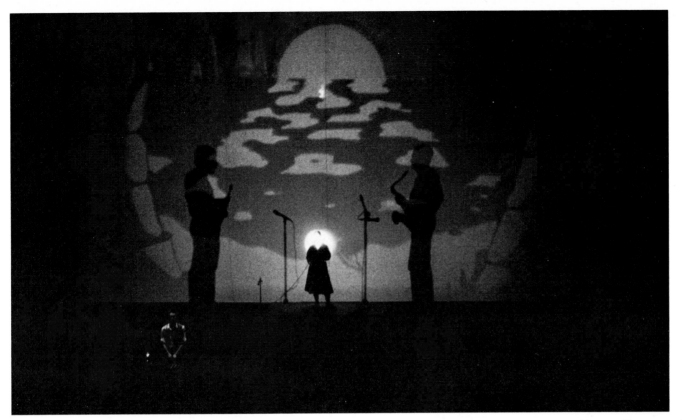

I got your letter. Thanks a lot.
I've been getting lots of sun. It's really
hot.
I always wondered who I'd bring
to a desert island.

Days,
I remember rooms.
Nights,
I swim in the blue lagoon.

I saw a plane today flying low
over the island.
But my mind
was somewhere else.

And if you ever
get this letter:
Thinking of you.
Love and kisses . . .
Blue
Pacific
signing off.

HOTHEAD (LA LANGUE D'AMOUR)

Voyons . . . euh . . . c'était sur une île. Il y avait un serpent et ce serpent avait des jambes. Et il pouvait marcher tout autour de l'île.

Let's see . . . uh . . . it was on an island. There was a snake and this snake had legs. And he could walk all around the island.

Oui, c'est vrai. Un serpent avec des jambes.

Yes, that's true. A snake with legs.

Et l'homme et la femme étaient aussi sur l'île. Et ils n'étaient pas très malins, mais ils étaient heureux comme des poissons dans l'eau. Oui.

And the man and the woman were on the island too. And they were not very smart, but they were happy as clams. Yes.

Voyons . . . euh . . . alors un soir le serpent faisait un tour dans le jardin en parlant tout seul et il vit la femme et ils se mirent à parler. Et ils devinrent amis. De _très_ bons amis.

Let's see . . . uh . . . then one evening the snake was walking about in the garden and he was talking to himself and he saw the woman and they started to talk. And they became friends. _Very_ good friends.

Et la femme aimait beaucoup le serpent parce que quand il parlait il emettait de petits bruits avec sa langue et sa longue langue lui lechait légèrement les lèvres.

And the woman liked the snake very much because when he talked he made little noises with his tongue and his long tongue was lightly licking about his lips.

Comme s'il y avait un petit feu à l'interieur de sa bouche et que la flamme sortit en dansant de sa bouche. Et la femme aimait beaucoup cela.

178

Like there was a little fire inside his mouth and the flame would come dancing out of his mouth. And the woman liked this very much.

Et après cela elle se mit à trouver l'homme ennuyeux par ce que quoiqu'il advint, il était toujours aussi heureux qu'un poisson dans l'eau.

And after that she was bored with the man because no matter what happened, he was always as happy as a clam.

Que dit le serpent? Oui, que disait le serpent?

What did the snake say? Yes, what was he saying?

OK. Je vais vous le dire.

OK. I will tell you.

Le serpent lui raconta des choses sur le monde.

The snake told her things about the world.

Il lui parla du temps où il y eut un grand tiphon sur l'île et où tous les requins sortirent de l'eau.

He told her about the time when there was a big typhoon on the island and all the sharks came out of the water.

Oui, ils sortirent de l'eau et ils vinrent droit dans votre maison avec leurs grandes dents blanches. Et la femme entendit ces choses et elie tomba amoureuse.

Yes, they came out of the water and they walked right into your house with their big white teeth. And the woman heard these things and she was in love.

Et l'homme vint et lui dit: "Il faut qu'on s'en aille maintenant," et la femme ne voulait pas s'en aller par ce qu'elle était une brulée. Parce qu'elle était une femme amoureuse.

179

And the man came out and said: "We have to go now," and the woman did not want to go because she was a hothead. Because she was a woman in love.

Toujours est-il qu'ils montèrent dans leur bateau et quitterent l'île.

Anyway, they got into their boat and left the island.

Mais ils ne restaient jamais très longtemps nulle part. Parce que la femme ne pouvait trouver le repos.

But they never stayed anywhere very long. Because the woman was restless.

C'était une tête brulée. C'était une femme amoureuse.

She was a hothead. She was a woman in love.

Ce n'est pas une histoire que raconte mon peuple. C'est une langue que je sais par moi-meme.

This is not a story my people tell. It's something I know myself.

Et quand je fais mon travail je pense à tout cela.

And when I do my job I am thinking about these things.

Parce que quand je fais mon travail, c'est ce à quoi je pense.

Because when I do my job, that's what I think about.

Oooo là là là là.	Yeah. La. La. La. La.
Voici. Voilà.	Here and there.
Oooo là là là là.	Oh yes.
Voici le langage de l'amour.	This the language of love.
Oooo là là là là.	Oooo. Oh yeah.
Voici. Voilà là là.	Here it is. There it is. La la.
Voici le langage de l'amour.	This is the language of love.
Ah! Comme ci, comme ca.	Ah! Neither here nor there.
Violà. Violà.	There. There.
Voici le langage de l'amour.	This is the language of love.
Voici le langage de l'amour.	This is the language of love.
Attends! Attends! Attends!	Wait! Wait! Wait!
Attends! Attends! Attends!	Wait! Wait! Wait!
Ecoute. Ecoute. Ecoute.	Listen. Listen. Listen.
Oooo là là là là.	Oooo. Oh yeah.
Oooo là là là là	Oh yeah. Yeah.
Voici le langage de l'amour.	This is the language of love.
Voici le langage dans mon coeur.	This is the language of my heart.
Oooo là là là là.	Oooo. Oh yeah.
Voici le langage dans mon coeur.	This is the language of my heart.
Voici le langage de l'amour.	This is the language of love.
Voici le langage dans mon coeur.	This is the language of my heart.
Voici le langage dans mon coeur.	This is the language of my heart.

...ROCK THE CRADLE... RULE THE WORLD... REACH FOR THE SKY...

...LAY OF THE LAND.... SHOP AND SAVE...

HOME OF THE BRAVE......... ROCK THE CRADLE...

LET SLEEPING DOGS AND SITTING DUCKS LIE..........

LONG TIME NO SEE... LONG TIME NO SEE......

ONE NIGHT STAND......

...JOIN OR DIE... WEIGHT OF THE WORLD.....

DOG EAT DOG... LOVE IT OR LEAVE IT...

 JOIN OR DIE...

OVER THE RIVER... AND THRU THE WOODS...

 ROCK THE CRADLE... .LONG TIME NO SEE...

LISTEN TO THE MOCKINGBIRD..........

STIFF NECK

A while ago, I had this stiff neck. I couldn't get it out of this one position. I went to a doctor and he said: I'm afraid this is no stiff neck—I think we're going to have to operate right away. I couldn't believe it so I went to a few specialists and they all said the same thing—we'll have to operate immediately. So I finally decided to have the operation and right before, the doctor said: Oh, by the way, what kind of insurance do you have? And I said: I don't have any insurance. And he said:

Well, maybe we can wait on this.

By this time I was convinced I really needed to have the operation so I went to one last guy—and the first thing I said when I walked into his office was: Look. I have no money and no insurance. And he said: Show me where it hurts. And I said: Well, it sort of starts in my neck here, and runs down my arm, and kind of crumples up the fingers on this hand. And he said:

Exactly what is it that you do for a living?

TELEPHONE SONG

(On telephone) Hi. How are you? What are you doing? Yeah, I know, it's kind of noisy here. There's kind of a party going on. Why don't you just come over. Just put on your coat and call a cab and come over. Yeah, I know you're asleep—but it's really fun—you'd have a really good time. Just put on your shoes and call a cab and come over. No, he's not here. Well, maybe he's here—maybe he's not here. What's the difference? Yeah, I know it's Brooklyn. Yeah, well, what's thirty bucks? It's two nights. OK. OK. Listen, I'm sure I could get you in.

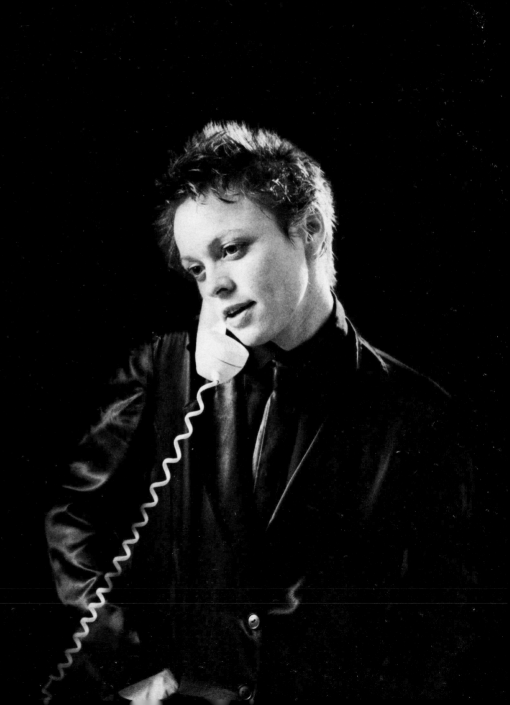

SWEATERS

I no longer love
your mouth.
I no longer love
your eyes.
I no longer love your eyes. I no longer
love the color of your sweaters.
I no longer love the color
of your
sweaters.
I no longer love the way you hold
your pens
and pencils.
I no longer love it.
Your mouth,
Your eyes,
The way
you hold your pens and pencils.

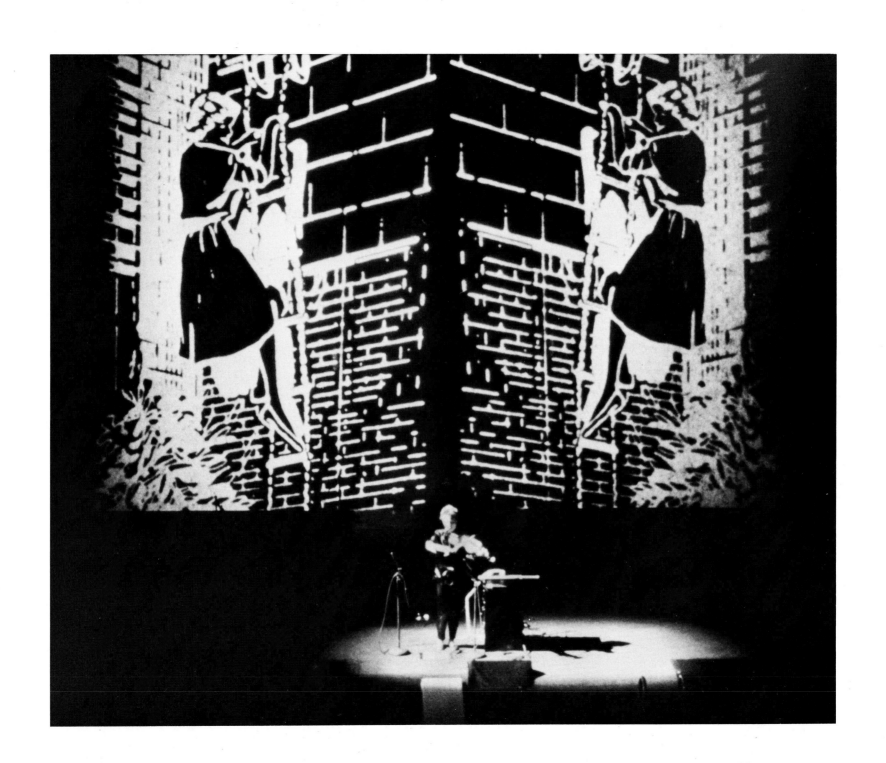

We've Got Four Big Clocks

(and they're all ticking)

SONG FOR TWO JIMS

A while ago I was camping out in Kentucky. I was sleeping out under this ledge and about three in the morning I woke up. The fire was out but I could see two boots standing a few feet away. I crawled out and there was a guy standing there holding a musket. He said: We eat critters. And I said: What? He said: We eat critters—you know, possum, squirrel, night animals. We hunt 'em at night.

He said he didn't think it was a good idea for a woman to be alone in those parts—and he invited me back to his house. I followed him and ended up staying a week. His name was Mr. Taylor and he was married to Mrs. Taylor. They were also brother and sister—but they didn't think that was too strange because their parents were brother and sister too. There were four Taylor kids—Jack, Jim, Rhonda and Jim. Two Jims—who knows why. We'd get up every day and sort of hack around in the tobacco patch and when it got too hot we'd just sit around on the porch and sort of stare out.

The landscape around there was completely desolate except for the tobacco plants. Standard Oil had strip-mined it in the thirties, and just when some vegetation was beginning to grow back, they discovered that a certain kind of low-grade shale could be converted to oil, so they came back in and drilled holes—very deep holes—hundreds of feet down into the bedrock. But they never got around to filling them afterwards. They just sent down a shipment of manhole covers, but nobody ever bothered to put them over the holes.

One day, Mrs. Taylor told me that she used to have another kid, but that he had apparently fallen down one of the holes. Her description was very abstract. Nobody tried to rescue him. He just fell down the hole. She said: "Well one day I saw him out there
and I was watching
and then I didn't see him out there no more."

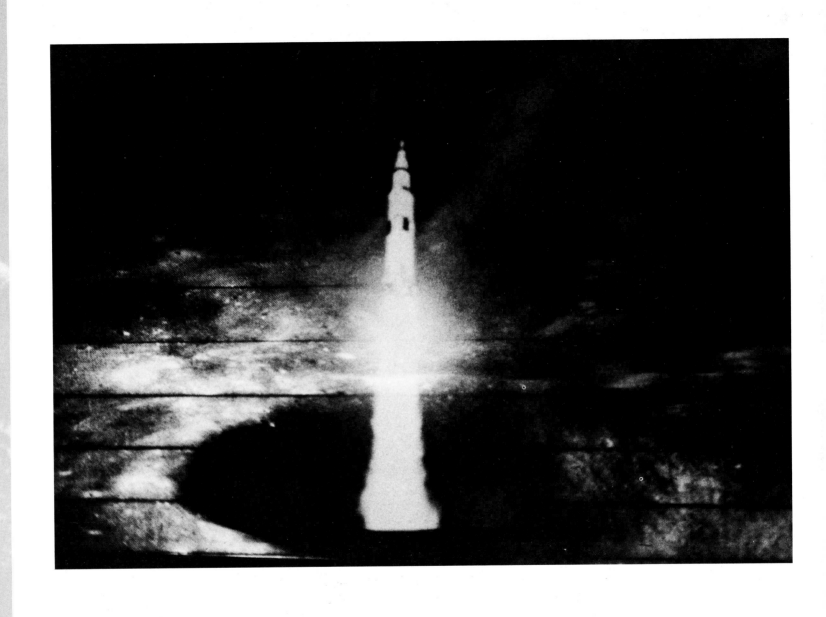

Over the river

And through the woods
Whose woods these are

Long time no see
Long time no see

MACH 20

Ladies and gentlemen, what you are observing here are magnified examples or facsimiles of human sperm.

Generation after generation of these tiny creatures have sacrificed themselves in their persistent, often futile, attempt to transport the basic male genetic code. But where is this information coming from? They have no eyes. No ears.

Yet some of them already know that they will be bald.

Some of them know that they will have small, crooked teeth.

Over half of them will end up as women.

Four hundred million living creatures, all knowing precisely the same thing—carbon copies of each other in a Kamikaze race against the clock.

Some of you may be surprised to learn that if a sperm were the size of a salmon it would be swimming its seven-inch journey at 500 miles per hour.

If a sperm were the size of whale, however, it would be traveling at 15,000 miles per hour, or Mach 20. Now imagine, if you will, four hundred million blind and desperate sperm whales departing from the Pacific coast of North America swimming at 15,000 mph and arriving in Japanese coastal waters in just under 45 minutes.

How would they be received?

Would they realize that they were carrying information, a message?

Would there be room for so many millions?

Would they know that they had been sent for a purpose?

JOIN, or DIE.

RISING SUN

THE VISITORS

A group of American minimal artists were on a goodwill trip to China. Near the end of their visit, they stopped in a remote province where few Americans had ever gone. One of the Chinese hosts seemed to be very confused about the United States. He kept asking questions like: "Is it true that Americans ride airplanes . . . to work?" "Is it true that all your food is made in factories?"

One of the artists was a conceptualist whose specialty was theories about information and truth. He decided to try out one of his theories on the host.

So when the host asked, "Is it true you have robots in your houses?" he said, "Yes, yeah. We have lots of them. It's true."

The host asked, "Is it true that Americans live on the moon?" The artist said, "Yeah, it's true. A lot of us live there. In fact, we go there all the time."

In this province, however, the word for moon was the same as the word for heaven. The hosts were amazed that Americans traveled to heaven. They were even more amazed that we were able to come back—that we went to heaven all the time.

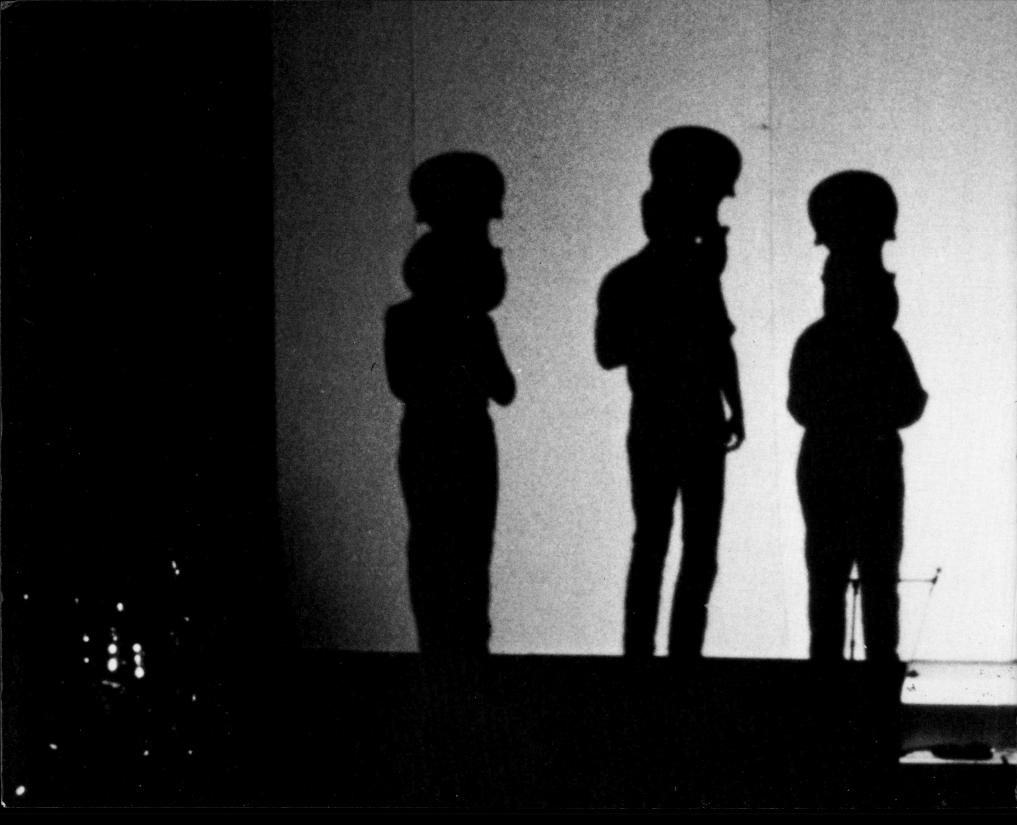

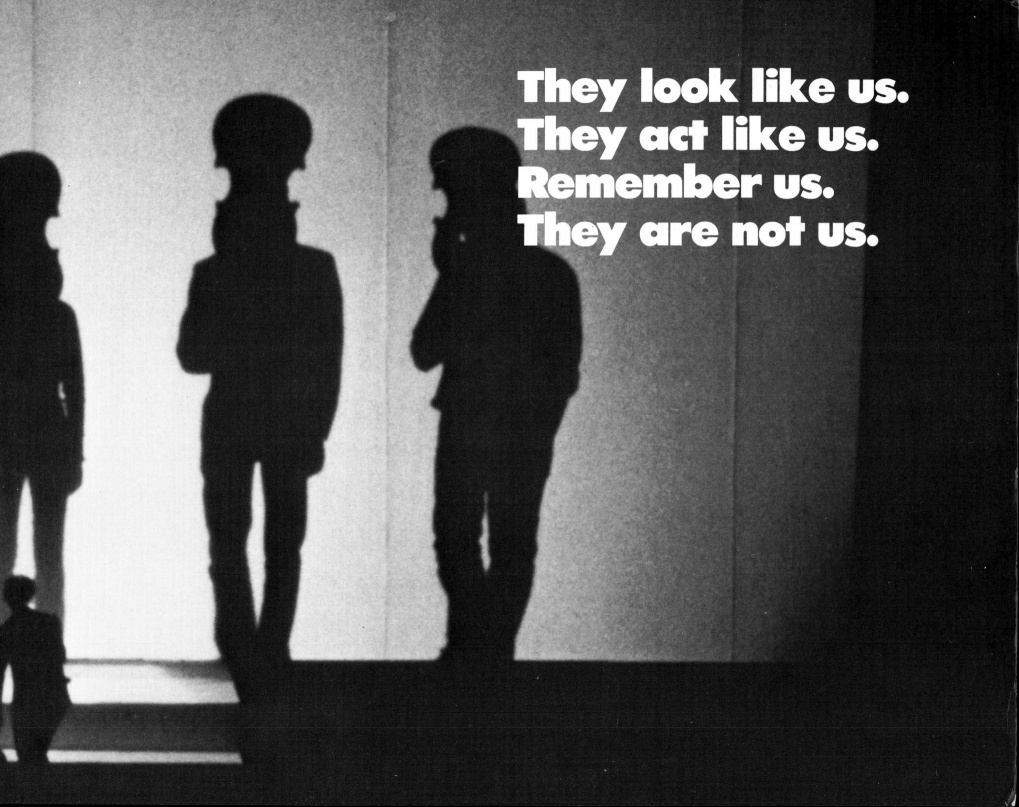

They look like us.
They act like us.
Remember us.
They are not us.

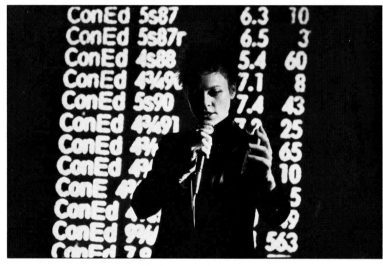

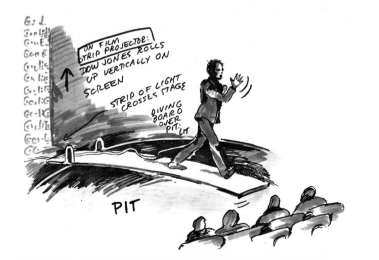

THE STRANGER

A stranger came into our town at twilight.
He said he had chosen our town out of all the other towns.
He said, "Roll out the red carpet."
He said, "I'm the one you have been waiting for."
He said, "I've come to serve you—no questions asked. So let's make a deal."
He said, "So put her here.
Let's shake on it. Give me five."
He said, "I've got a five-year plan. And we mean business.
So put her here.
Let's shake on it."

It's the one with the pool.

It's the one on the corner with the big garage.

It's the one with the fir tree in the front yard.

Leave the lights on.
It's twilight.

Why do you see the speck that is in your
brother's eye, but do not see the log that
is in your own eye?
Or how can you say to your brother,
"Brother let me take out the speck that is
in your eye," when you yourself do not
see the log that is in your own eye.

You hypocrite! First take the log out of your own eye and then you will see clearly to take out the speck that is in your brother's eye.

CLASSIFIED

I came home today and you had rearranged all the furniture.

And you had changed your name.

And I'd never seen you wear that pin-striped shirt before.

And then I realized, I was in the wrong house.

In this picture, there's a big blank piece of paper and I'm saying: Sign it.

Go ahead. It's blank. What have you got to lose?

And the sun's coming up and you still haven't signed it and I keep saying:

Sign it.

Sign it.

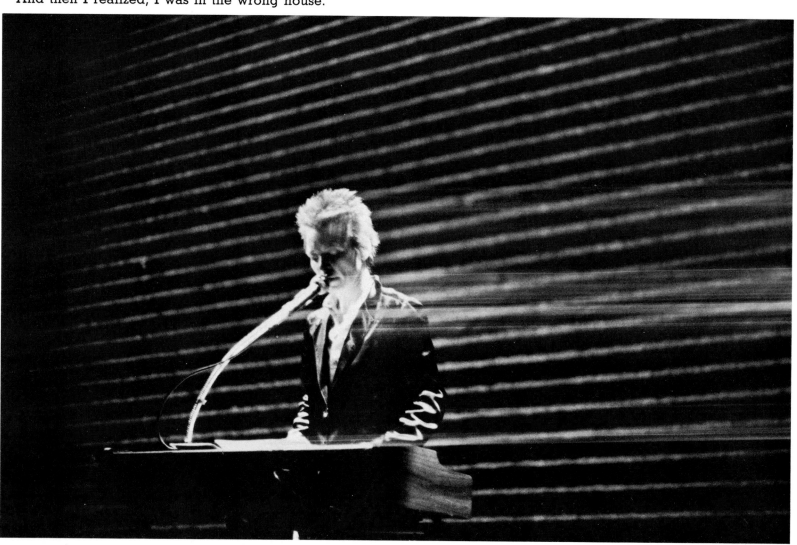

I'm going to draw a picture and I'm going to put in an
eight-lane superhighway and I'm going to draw you on
it in an old jalopy.
And then I'm going to draw a whole fleet of Mack
trucks barreling along the highway with their brights on.
And then I'm going to draw a flat tire on the jalopy
and then I'm going to draw the whole jalopy
in X-ray to show that you've got
no gas.

He said: You can take my money. You can take my life.
You can take my gun. You can take my wife.
But just make sure that when you do—
you take grandma too.

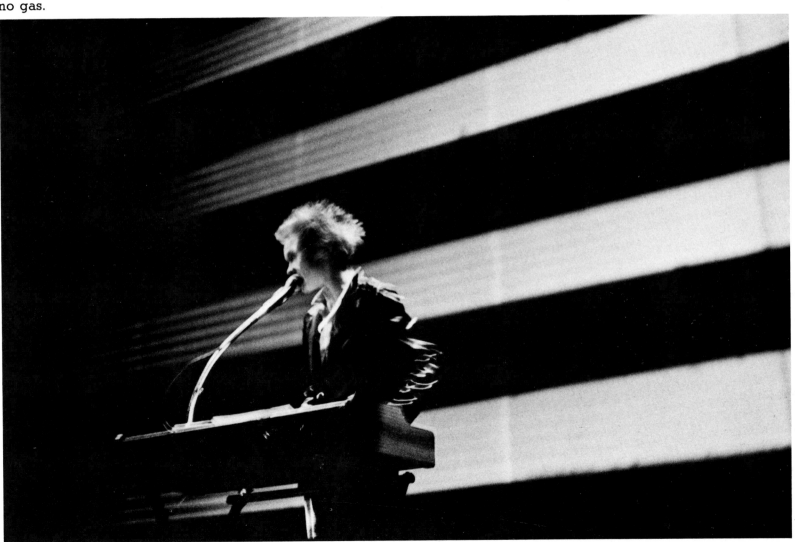

Hey! That sounds great!
That sounds really good!
Just don't put my name on it, OK?
Take my name off it,
all right?
Wish they all could be California girls.

tell our
we went
vacation

A nice Jewish guy 27, goys to earth, good job, sense of humor, seeks warm Fem counterpart, interested in music, art and more... VV Box P17632

Phone & photo... Box P17632

ANIMAL LOVER
Matronly Plain Jane 45, 5'7", w/kind heart, simple taste & good job, seeks SWM to age 55. VVVBoxM17207

225

sks discreet w/married...

Sucessful
Slim, attr, seeks
the best of both

SU...
No 1 winner in... most interesting person, one to... seeks interested friendly person. Send brief letter, tel #, photo. VVM4962

SWF, 35, super beauty

sks wonderful hi-calibre, educ SM. Incl phone. vvm10482

22 Accting Student CPA bound opinionated earthy fem-

Happy,
Seeks

Married tall handsome SWM 34 seeks slim intelligent attractive MSWF for discreet daytime affair. Please send letter & phone to VV P 5602

Mellow Yonkers dentist 29, short, cute, athletic, Jewish and happy seeks very thin bright pretty SJF, who's warm and athletic, loves sunshine and to laugh and will never grow old. VVM5933

man emotionally & finan-

Allendale NJ 07401

SWM, 33
Pisces
earth,
ry veg
Haiku

SWM, 23, very attractive, intelligent & creative, sks female company, also attractive, any age! NJ

personality, very grounded knowing what I need. I... meet a voluptuous, buxom straight, with a little bit in her, to give direc-
very good looking, built and very

VVM1764g

sensuous, intelligent WF, explore the city and each other

April-SWM, 25, seeks WF 20-30.

Get
HU

A nice Jewish guy 27, down to earth, good job, sense of humor, seeks warm J Fem counterpart, interested in film, music, art and more, for poss relatsp. Phone & photo please. VV Box P17852

ANIMAL LOVER
Matronly Plain Jane 45, 5'7", w/kind heart, simple taste & good job seeks SWM to age 55. VVVBoxM17207

A NJ Exec 38, 6', 190lbs, handsome, sks discreet dates in NJ, w/married or

I am a sincere, dynamic, prof black woman 32, who's lkng to shr gd food, gd wine and

I'D LIKE TO MARRY A MAN WHO PLAYS THE VIOLIN REALLY WELL, LOVES TO DANCE, IS IN HIS 40s & DOESN'T TALK TOO MUCH. VV M-16510

Very forceful personality, very grounded in myself and knowing what I need. I would like to meet a voluptuous, buxom lady 18-48 bi or straight, with a little bit of the little girl still in her, to give direction to. I am 37 cauc very good looking, very stable, very well built! and very VVBox P17214

Visiting NYC in April-SWM slim, sensuous, intell

Send photo, I'm a woman VV Box P17441

Is there a mature Asian woman 20-26? male/22/Amer-born/5'11"/140/kind-polite sks warm Asn (Chin/Fil/Jap. etc) woman who really wants friend-Descrp/Interests.VVP5588

Concert violinist, successful, SWM 31, very handsome, 5'10, slim, intell, quiet, many interests, seeks attr model-type, 20-29

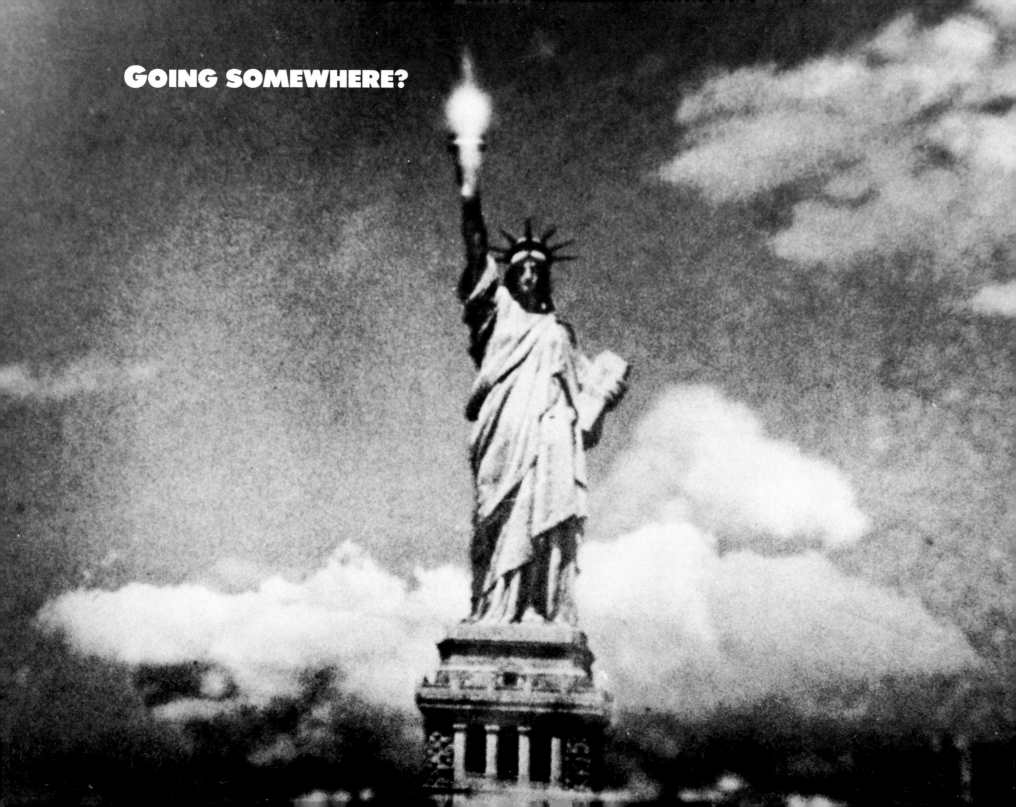

GOING SOMEWHERE?

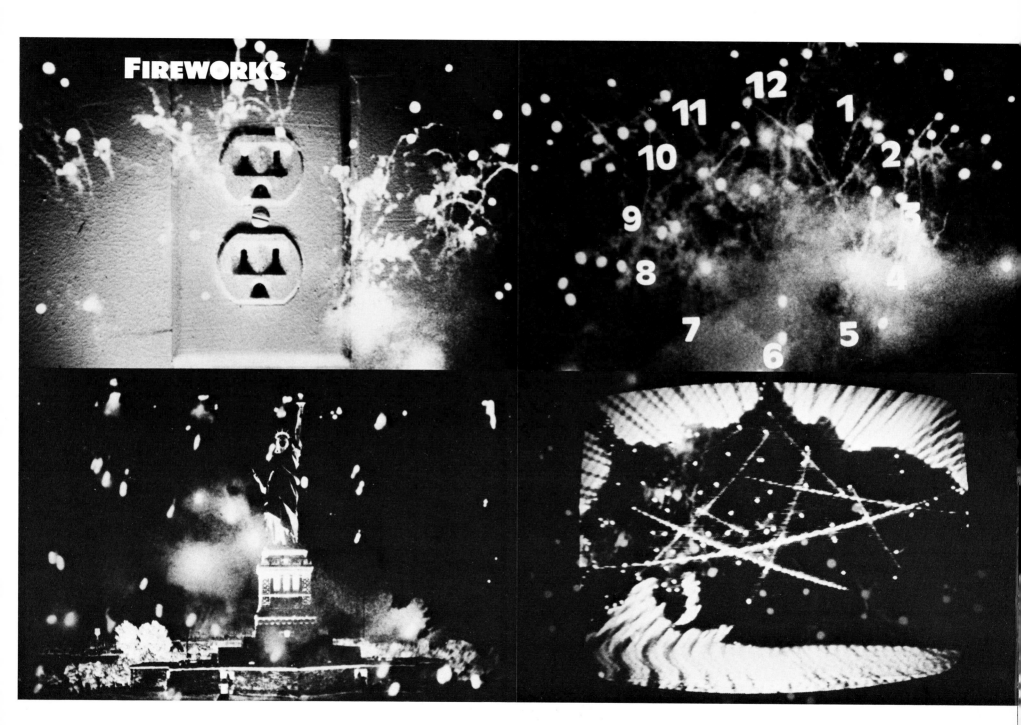

DOG SHOW

I dreamed I was a dog in a dog show.
And my father came to the dog show.
And he said: That's a really good dog.
I like that dog.

And then all my friends came and I
was thinking:
No one has ever looked at me like this
for so long.
No one has ever stared at me like this
for so long
for such a long time
for so long.

LIGHTING OUT
FOR THE TERRITORIES

You're driving and it's dark
and it's raining.
And you're on the edge of the city
and you've been driving all night.
And you took a turn back there
but now you're not sure it was the
right turn.
But somehow it looks familiar so you
just keep driving.

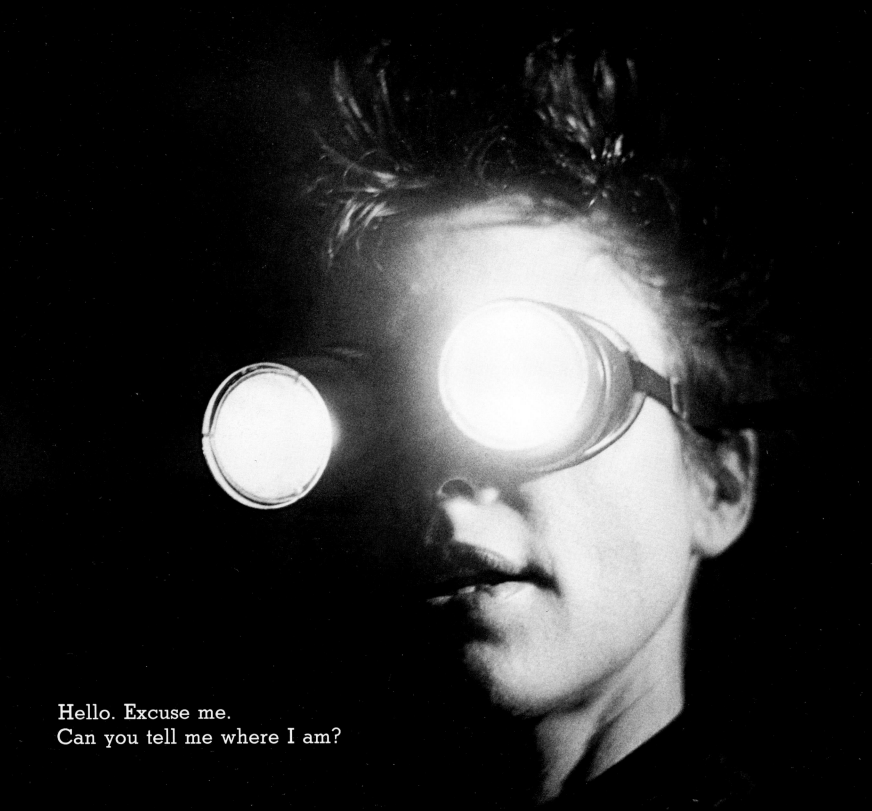

Hello. Excuse me.
Can you tell me where I am?

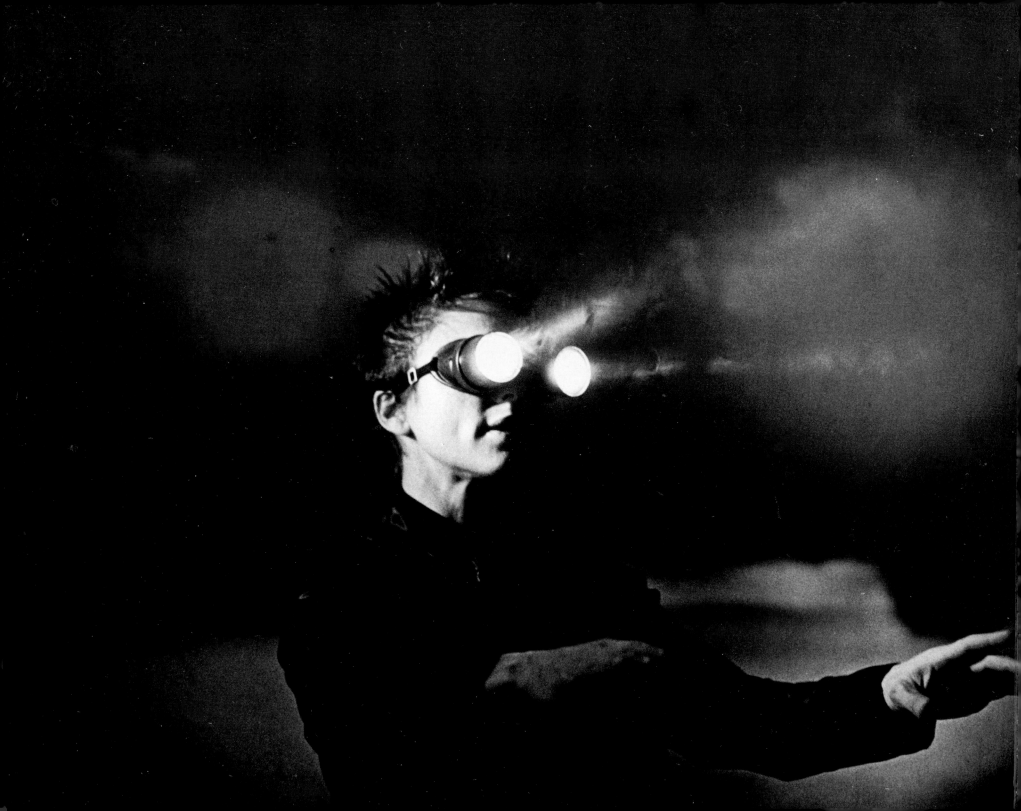

You've been on this road before.
You can read the signs.
You can feel your way.
You can do this
in your sleep.

APPENDIX

The World Premiere of UNITED STATES was at the Brooklyn Academy of Music, February 3–10, 1983

PART I

Peter Gordon Prophet synthesizer
Geraldine Pontius voice
Joe Kos voice
George Lewis tape

PART II

Ann DeMarinis OBXa and Synclavier
Bill Obrecht flute and sax
Chuck Fisher clarinet and sax
David Van Tieghem percussion and drums

PARTS III and IV

Chuck Fisher sax and clarinet
Bill Obrecht sax
David Van Tieghem percussion and drums
Ann DeMarinis OBXa and Synclavier
Rufus Harley bagpipes and sax
Shelley Carson soprano voice
George Lewis tape
Roma Baran accordion

Engineer: **Leanne Ungar**
Tape Operator: **Bob Davis**
Projectionist: **Perry Hoberman**
Assistant Projectionist: **Jacob Burckhardt**
Lighting Designer: **Jan Kroeze**
Assistant Lighting Designer: **Whitney Quesenbury**
Systems Design: **Bob Bielecki**
Production Manager: **William DeMull**
Assistant: **Britta Heimarck**

ABOUT THE ARTISTS

LAURIE ANDERSON has been doing performances since 1975. Her most recent record is *Mister Heartbreak* (Warner Bros.).

ROMA BARAN, independent producer, co-produced Laurie Anderson's *O Superman, Big Science,* and the mobile recording of these performances.

BOB BIELECKI is an electronic engineer. He also works as a consultant with many artists on projects involving musical engineering. He has collaborated on many recording and design projects with Laurie Anderson since 1975. He is currently doing research on piano acoustics with LaMonte Young.

JACOB BURCKHARDT has been making independent films for quite a while. He has run projectors in Venice, Belfast (Maine), Kyoto, and New York City. His latest film was *This Object* and the next is *It Don't Pay to Be an Honest Citizen.*

SHELLEY CARSON is at home on the opera stage as well as on the diving board. Since graduating from the Manhattan School of Music, she has made frequent appearances in recital and opera in the metropolitan area and at Aspen and Chautauqua summer festivals.

ROBERT COE (editor/dramaturg): articles on theater, dance, music and performance published in *The New York Times Magazine,* the *Village Voice,* and other periodicals. A play, *War Babies,* to be produced in 1984 by the Mark Taper Forum/Laboratory in Los Angeles. A book, *Dance in America,* for the WNET television series of the same name, to be published later this year. As a dancer, performed with Bill T. Jones and others, sang with Laurie Anderson and Des McAnuff. Lives in Chelsea.

ANNE DeMARINIS performed with Jeffrey Lohn, Glenn Branca, Sonic Youth and others. She is currently a member of the NYC band Interference, with Michael Brown, Joe Dizney, Karen Hagloff and David Linton.

WILLIAM DeMULL has worked as production manager, lighting designer and stage manager on several productions in the U.S. and Europe. He has designed lighting for numerous dance companies, including those of Meredith Monk, Kei Takei, The Dance Construction Co., John Driscoll, Douglas Dunn, Jan Van Dyke, Peggy Lyman and Bill T. Jones/Arnie Zane. He has served as production manager/lighting director for the Smithsonian Institution's modern dance series, and has taught lighting design at George Washington University and Bennington College. Recently, he has collaborated on projects incorporating his designs of reflected light environments and fluorescent light sets.

CHARLES FISHER (reeds) is a free-lance musician living in New York City. A graduate of the New England Conservatory, he has worked with Jaki Byard, Charles Persip, Tito Puente, and is active in the commercial recording studios.

PETER GORDON first began working in New York City in 1975 as a saxophonist for a variety of rock and avant-garde artists. In 1977 he started composing music for, performing with, and co-directing (with David Van Tieghem) the Love of Life Orchestra, one of the earliest and best-known new music/rock fusion big bands. He also works as a solo artist and is known for his recent "tone poems," such as *Frozen Moments of Passion,* which incorporate solo saxophone playing, spoken fragments and prerecorded material. Peter Gordon is also known as an arranger, record producer and radio producer. In 1982 he formed a video/music production company, *Antarctica,* with John Sanborn and Kit Fitzgerald.

RUFUS HARLEY, the world's first jazz bagpipe player, also performs on tenor and soprano sax. He just performed at Pennsylvania Governor Thornburgh's mansion at a dinner honoring the cabinet, received a standing ovation and was asked back to perform for the governor's inauguration. His tenor sax can be heard in the film *Eddie and the Cruisers.*

BRITTA HIEMARCK is currently a music major at Brown University and has studied flute and piano for over ten years. She was co-writer and co-producer of a play and multimedia work for the Brown Disarmament Group and has performed with the Jupiter Symphony in Damrosch Park at Lincoln Center, as well as many smaller concerts, improvisations and synclavier work.

PERRY HOBERMAN is an artist who lives in Brooklyn. His installations include "Out of the Picture: Return of the Invisible Man" at Artists' Space and a showing at MIT's Hayden Gallery in Boston. Starting with the premiere of Part I of *United States* in 1979, he has worked regularly as the projectionist for Parts I–IV, often doubling as a backup musician. He is the inventor and operator of the Duck's Foot Dissolve, the main projection system used in *United States.* The present system has grown out of what was originally a hastily improvised response to an emergency during a concert in Bern, Switzerland: cardboard flaps weighted with Swiss coins pulled by ropes, a kind of buck-board wagon technology.

JOE KOS, artist and percussionist, has performed in numerous music ensembles and has appeared in four Laurie Anderson performances. He has also exhibited video work and sculpture in New York City and has had his graphic work published in several art periodicals.

JAN KROEZE is a New York–based lighting designer. His most recent credits include: The Big Apple Circus at Lincoln Center, Judy Pfaff at the Holly Solomon Gallery, Eric Sevareid's *Chronicle*—a nationally syndicated series—and *The Double Dutch Tapes,* nominated for three Emmys this year.

BILL OBRECHT is a saxophonist and composer. In addition to his performance and recordings with Laurie Anderson, Obrecht has worked with a wide range of artists and groups, including Leslie Gore, the Love of Life Orchestra, Sarah Dash, Red Decade, the Goldman Concert Band, and his own group—La Guapa Papa. Obrecht's compositions have been performed in art spaces and clubs throughout New York.

GERALDINE PONTIUS, an artist living and working in New York, has participated in Laurie Anderson's work for fifteen years, as well as other shows.

LEANNE UNGAR is an independent recording engineer. She has recorded numerous albums, most recently of note, *Big Science* for Laurie Anderson.

DAVID VAN TIEGHEM is a percussionist, composer and performer based in New York City. He has recorded with Steve Reich, Jon Gibson, Brian Eno, David Byrne, Garland Jeffries, Talking Heads and Robert Ashley, among others. He co-directs the Love of Life Orchestra with Peter Gordon, and collaborates with video artists John Sanborn and Kit Fitzgerald to create new music/video works for television. Since 1977, he has been presenting his solo percussion-theater performance, *Message Received … Proceed Accordingly (A Man and His Toys),* at venues throughout North America and Europe. He is currently at work on a solo record of his music.

Americans on the Move, commissioned by Holly Solomon, was first presented at Carnegie Recital Hall in February 1979 to honor Horace Solomon's fiftieth birthday. Part I of *United States* was first presented at The Kitchen in the spring of 1979; Part II at the Orpheum Theater, sponsored by The Kitchen and coordinated by Jacki Kain. Part IV was commissioned by the Brooklyn Academy of Music. Other parts have been commissioned and supported by the Holly Solomon Gallery, the Franklin Furnace (coordinated by Susan Martin) and 110 Records (B. George). The performances were supported by grants from the National Endowment for the Arts and the Guggenheim Foundation.

Born, Never Asked is adapted from a work for orchestra commissioned and performed by the Oakland Youth Symphony in 1980, conducted by Robert Hughes.

The song *"Big Science"* was originally part of the work *It's Cold Outside,* commissioned by the American Composers Orchestra and performed by them in November 1981, conducted by Dennis Russell Davies.

Words for *"The Stranger,"* *"Mach 20,"* *"Blue Lagoon,"* *"Let X= X,"* *"Language Is a Virus"* and *"Yankee See"* were written with Robert Coe. Additional words and corrections for Parts I–IV by Robert Coe.

"Dr. Miller" was written with Perry Hoberman.

The projection system was designed by Perry Hoberman. Additional projector design by Paul Weller. Electric glasses designed and constructed by Frederick Buchholz. Diving board and pool equipment courtesy of A-1 Pool Center, Barry Kaplan, proprietor, Brooklyn, New York.

As a work-in-progress, *United States: Parts I–IV* has been performed in many places, most recently in the Festival d'Automne (Paris), Zuercher Theater Spektakel (Zurich), Adelphi Theatre (London), Kabuki Theater (San Francisco), The Roxy (Los Angeles) and the Westdeutscher Rundfunk Köln (Cologne).

Laurie Anderson's recordings include: *It's Not the Bullet That Kills You—It's the Hole,* Holly Solomon Gallery, 1977; selections on *Airwaves* (an anthology of artists' works), 110 Records, 1977; *New Music for Electronic and Recorded Media,* 1750 Arch Street Records, 1977; *The Nova Convention,* Giorno Poetry Systems, 1979; *Big Ego,* Giorno Poetry Systems, 1979; *O Superman/Walk the Dog,* Warner Bros. Records, 1981 (originally released on 110 Records); *You're the Guy I Want to Share My Money With* (with John Giorno and William S. Burroughs), Giorno Poetry Systems, 1982; *Big Science,* Warner Bros., 1982 (co-produced with Roma Baran; assistant producer, Perry Hoberman; engineer, Leanne Ungar); *Let X = X* (flexidisk commissioned by *Artforum* magazine), 1982; *Mister Heartbreak,* Warner Bros., 1984 (coproduced with Roma Baran and Bill Laswell; engineer, Leanne Ungar).

Special thanks to: Robert Hyde Busler, Jr., Yolanda Lynn Cole, Bob Bielecki, Greg Shifrin, Gail Turner, Alec Bernstein, Hans Keller, Charles Amirkhanian, Bérénice Reynaud, Robert Coe, Bice Curiger, Jacqueline Burckhardt, Peter Matorin, Roma Baran, John. Also, William S. Burroughs and Captain Beefhart.

PERFORMANCES

1972

"Automotive": Town Green, Rochester, Vermont.

1973

"O-Range": Lewisohn Stadium, City College, New York City.
Artists Space, New York City.
The Clocktower, New York City.
Projects Gallery, Boston, Massachusetts.
"Duets on Ice": 5 New York City outdoor locations; 5 outdoor locations in Genoa, Italy (with Samangallery).

1975

Whitney Museum, Downtown Branch (music), New York City.
Artists Space, New York City.
Oberlin College, Oberlin, Ohio.
University of Massachusetts, Amherst, Massachusetts.
Holly Solomon Gallery, New York City.
Sarah Lawrence College, Bronxville, New York.
Rhode Island School of Design, Providence, Rhode Island.

1976

Museum of Modern Art, New York City.
Whitney Museum of American Art, New York City.
Brockport College, Brockport, New York.
"Fast Food" (with "Fast Food Band"): Artists Space, New York City.
Skidmore College, Saratoga, New York.
Philadelphia College of Art, Philadelphia, Pennsylvania.
California Institute of the Arts, Valencia, California.
University of California, San Diego, La Jolla, California.
Museum of Contemporary Art, La Jolla, California.
M. L. D'Arc Gallery, New York City.
Akademie der Kunst, Berlin, Germany.
Louisiana Museum, Humlebaek, Denmark.
St. Mark's Poetry Project, New York City.
The New School, New York City.

1977

The Kitchen, New York City.
School of Visual Arts, New York City.
De Appel, Amsterdam, Holland.
Arte Fiera, Bologna, Italy.
International Cultural Center, Antwerp, Belgium.
Documenta, Kassel, Germany.
Biennale, Paris, France.
Galleria Salvatore Ala, Milan, Italy.
Art Park, Lewiston, New York.
Museum of Contemporary Art, Chicago, Illinois.

1978

Otis Art Gallery, Los Angeles, California.
And/Or Gallery, Seattle, Washington.
The Kitchen (benefit performance), New York City.
The Ear Inn (reading), New York City.
Walker Art Center (with St. Paul Chamber Orchestra), Minneapolis, Minnesota.
Texas Opry House (with Contemporary Art Museum), Houston, Texas.
Mills College, Oakland, California.
Wright State University Residency Program: Wright State University, Dayton, Ohio.
Moore College of Art, Philadelphia, Pennsylvania.
University of New Mexico, Albuquerque, New Mexico.
University of California, Long Beach, California.
Portland Center for the Visual Arts, Portland, Oregon.
DC Space, Washington, D.C.
Benefit for Hallwalls, Buffalo, New York.
Contemporary Art Center, Cincinnati, Ohio.
Real Art Ways, Hartford, Connecticut.
Art Gallery of Ontario, Toronto, Canada.
"One World Poetry": Het Tweed International Dichters Festival, Rotterdam, Holland.

1979

Carnegie Recital Hall, New York City.
The Kitchen, New York City.
Theater of Nations Festival, Hamburg, Germany.
Groningen Museum, Groningen, Holland.
International Cultural Center, Antwerp, Belgium.
Dany Keller Gallery, Munich, Germany.
Cultural Center, Bonn, Germany.
Customs House, New York City.
Autumn Festival, Paris, France.
CAPC, Bordeaux, France.
OGGImusica Festival, Lugano, Switzerland.
Real Art Ways, Hartford, Connecticut.
San Francisco Art Institute, San Francisco, California.
Mills College, Oakland, California.
Northwestern University, Thorne Hall, Chicago, Illinois.
University of Virginia, Richmond, Virginia.
Glenbow Museum, Calgary, Alberta, Canada.
Modern Art Gallery, Vienna, Austria.
Stadtparkforum, Graz, Austria.
Aspen Center for the Visual Arts, Aspen, Colorado.
The Mudd Club (with Peter Gordon), New York City.
Customs House (with Peter Gordon), New York City.
Kunsthalle Basel, Basel, Switzerland.

1980

Für Augen Und Öhren, Akademie der Kunst, Berlin, Germany.
Santa Barbara Museum of Art, Santa Barbara, California.
Per/for/mance Festival, Florence, Italy.
Harvard University, Cambridge, Massachusetts.
Rome Performance Festival, Rome, Italy.
New Music America, Walker Art Center, Minneapolis, Minnesota.
Parachute Magazine Performance Series, Montreal, Canada.
University of Northern Iowa, Cedar Falls, Iowa.
Levande, Goteborg, Sweden.
Paul Klee Kunstmuseum, Bern, Switzerland.
Kunstmuseum, Zurich, Switzerland.
Mixage International, Rotterdam, Holland.
Rust/Roost, Middleburg, Holland.
ROSC, Dublin, Ireland.
Benefit for Volume Magazine, Irving Plaza, New York City.
Lenbachhaus, Munich, Germany.
Paramount Theater (with Oakland Youth Symphony), Oakland, California.
Orpheum Theater, (sponsored by The Kitchen), New York City.

1981

Glenbow Museum, Calgary, Alberta, Canada.
Art Institute, Kansas City, Missouri.
University of Virginia, Blacksburg, Virginia.
Western Front, Vancouver, B.C., Canada.
York University, Toronto, Canada.
Kunstmuseum, Basel, Switzerland.
Cirque Divers, Liège, Belgium.
Pension Building (sponsored by DC Space & WPA), Washington, D.C.
Institute of Art, Detroit, Michigan.
Institute of Contemporary Art, Philadelphia, Pennsylvania.
University of California, Davis, California.
University of California, San Diego, California.
Palais de Beaux Arts, Brussels, Belgium.
One World Poetry Festival, Amsterdam, Holland.
Kunsthaus, Zurich, Switzerland.
Riverside Studios, London, England.
Centre d'Arts Plastiques, Bordeaux, France.
"New Music America": Kabuki Theater, San Francisco, California.
Rimini Festival, Sant' Arcangelo, Italy.
Theater der Welt, Cologne, Germany.
Franklin Furnace Benefit, New York City.
Seattle Art Museum, Volunteer Park, Seattle, Washington.
Cinema Theater, San Francisco, California.
Roxy Theater, Los Angeles, California.
University of Connecticut, Storrs, Connecticut.
The Ritz, New York City.
Vancouver New Music Society, Vancouver, Canada.
Alice Tully Hall (with American Composers Orchestra), Lincoln Center, New York City.

1982

Westdeutscher Rundfunk Köln (live radio broadcast), Cologne, Germany.
Wurttembergische Stadttheater, Stuttgart, Germany.
Neighbors of Woodcraft Hall (sponsored by Portland Center for the Visual Arts), Portland, Oregon.
Moore Theatre (sponsored by On-The-Boards), Seattle, Washington.
Kabuki Theatre, San Francisco, California.
The Roxy, Los Angeles, California.
University of California, Los Angeles, Royce Hall, Los Angeles, California.
Rice University, Houston, Texas.
Carnegie Music Hall (sponsored by Pittsburgh Film-Makers), Pittsburgh, Pennsylvania.
Oberlin College, Oberlin, Ohio.
Park West (sponsored by Museum of Contemporary Art), Chicago, Illinois.
University of Minnesota (sponsored by Walker Art Center), Minneapolis, Minnesota. •
Palladium, New York City.
The Bergen Festival-Den Nationale Scene, Bergen, Norway.
Sonja Henie–Niels Onstad Foundations, Oslo, Norway.
Moderna Museet, Stockholm, Sweden.
Louisiana Museum of Modern Art, Humlebaek, Denmark.
Adelphi Theater, London, England.
Queens Hall, Edinburgh, Scotland.
Zuercher Theater Spektakel, Zurich, Switzerland.
Santa Monica Civic Center, Santa Monica, California.
Kool Jazz Festival, Los Angeles, California.
Theatre Bobino–Festival d'Automne, Paris, France.

1983

Dominion Theatre, London, England.
Volkhaus, Zurich, Switzerland.
Olympic Theatre, Rome, Italy.
Conservatori, Milan, Italy.
Vienna Concert House, Vienna, Austria.
Warner Theatre, Washington, D.C.
Berklee Performance Center, Boston, Massachusetts.
Santa Cruz Civic Auditorium, Santa Cruz, California.
Warfield Theatre, San Francisco, California.
Perkins Palace, Pasadena, California.
Rainbow Theatre, Denver, Colorado.
Park West, Chicago, Illinois.
McAllister Auditorium, Tulane University, New Orleans, Louisiana.

PUBLICATIONS

The Package: a Mystery (Bobbs-Merrill, New York), 1971.
October, privately printed (New York), 1972.
Transportation/Transportation, privately published (New York), 1973.
The Rose and the Stone, privately printed (New York), 1974.
Artpark 77, "Stereo Decoy" (New York), 1977.
Individuals, from "For Instants" (E. P. Dutton, New York), ed. Alan Sondheim, 1977.
Notebook (Collation Center Artist's Books Series, New York), 1977.
Art Rite, "Autobiography: the Self in Art," June/July 1978.
October, from "Americans on the Move," Spring 1979.
Ear, "Three Architexts," vol. 4, No. 5/6, Summer 1979.
Performance by Artists, notes from "Like a Stream" (Art Metropole, Toronto, Canada), ed. A.A. Bronson and Peggy Gale, 1979.
Top Stories #2, "Words in Reverse" (Hard Press, Buffalo, New York), 1979.
The Drama Review, "Americans on the Move, Parts I and II," vol. 24, No. 2, June 1980.
Artforum, "Projects," February 1980.
Musica 80, "Americans on the Move" (Milano) February 1980.
High Performance, "Artist's Notes," No. 10, 1980.
Hotel, "Dark Dogs, American Dreams" (Tanam Press, New York), 1980.
Express, "U.S.A.," Summer 1981.
Performance Text(e)s & Documents, "United States: Part II" (Montreal, Canada), 1981.
Wochen Programm, excerpts from "United States" (Montreal, Canada), 1981.
American Artists on Art from 1940 to 1980, Interview by Robin White (Harper & Row, New York), ed. Ellen H. Johnson, 1982.

DISCOGRAPHY

1977

It's Not the Bullet that Kills You—It's the Hole, 45 rpm, Holly Solomon Gallery, New York City.
Airwaves (selections), 110 Records, New York City.
New Music for Electronic and Recorded Media, 1750 Arch Street Records, Berkeley, California.

1979

The Nova Convention (selections), Giorno Poetry Systems.
Big Ego (selections), Giorno Poetry Systems.

1981

Word of Mouth, Crown Point Press.
O Superman, 7" EP, 110 Records/Warner Bros.

1982

You're the Guy I Want to Share My Money With (with John Giorno and William Burroughs), Giorno Poetry Systems.
Big Science, LP, Warner Bros.

1984

Mister Heartbreak, LP, Warner Bros.

FILMS

1979

Fourteen Americans, Michael Blackwood Productions, New York City.

1981

Film du Silence, Catherine Lahourcade (Channel 3), Paris, France.

ONE-PERSON EXHIBITIONS

Barnard College, New York City, 1970.
Harold Rivikin Gallery, Washington, D.C., 1973.
Artists Space (sponsored by Vito Acconci), New York City, 1974.
Holly Solomon Gallery, New York City, 1977.
Hopkins Center, Dartmouth College, Hanover, New Hampshire, 1977.
And/Or, Seattle, Washington, 1978.
Museum of Modern Art (Projects Gallery), New York City, 1978.
Matrix Gallery, Hartford Athenaeum, Hartford, Connecticut, 1978.
Holly Solomon Gallery, New York City, 1980.
Holly Solomon Gallery, New York City, 1981.
"Laurie Anderson, Retrospective: 1969–1983," The Institute of Contemporary Art, Philadelphia; The Fred S. White Gallery, Los Angeles; The Contemporary Arts Museum, Houston; The Queens Museum, New York; 1983–1984.

GROUP EXHIBITIONS

1972

"Story Show," John Gibson Gallery, New York City.

1973

"Thought Structures," Pace University, New York City.

1974

"About 405 East 13th Street," New York City.
"Women Conceptual Artists," traveling; curator: Lucy Lippard.

1975

"Narrative in Contemporary Art," Guelph, Ontario, Canada.
Group Show, Holly Solomon Gallery, New York City.
"Not Photography," Artists Space; curator: Edit deAk, New York City.
"Self-Portraits," Artists Space; curator: Susan Pensner, New York City.
"Lives," Fine Arts Buildings; curator: Jeffery Deitch, New York City.

1976

"Autogeography," Whitney Museum, Downtown Branch, New York City.
"Performance/Object," Holly Solomon Gallery, New York City.
"Non-Collectible Art from the Collection of Holly and Horace Solomon," Sarah Lawrence College, Bronxville, New York.
"Choice," Yale School of Arts, New Haven, Connecticut.
"New York/New York," Fine Arts Gallery, California State University, Los Angeles, California.
"Line Up," Museum of Modern Art, New York City.

1977

"Works on Paper," Holly Solomon Gallery, New York City.
"Artist by Artist," Art Lending Service, Museum of Modern Art, New York City.
"Homecoming," PS I, Institute of Urban Resources, Long Island City, New York.
"Surrogates/Self-Portraits," Holly Solomon Gallery, New York City.
"Words at Liberty," Museum of Contemporary Art, Chicago, Illinois.
"Words," Whitney Museum of American Art, New York City.
"A Collection of New Art for Jimmy Carter," Georgia Museum of Art, Atlanta, Georgia.

1978

"American Narrative Story Art," Contemporary Art Museum, Houston, Texas.
"Narration," Institute of Contemporary Art, Boston, Massachusetts.
"Architexts," And/Or, Seattle, Washington.
"The Sense of Self; from Self-Portrait to Autobiography," traveling, Independent Curators, Inc.
"16 Projects/4 Artists," Moore College of Art, Wright State University, Dayton, Ohio.
"Laurie Anderson, The Handphone Table," Performance Art Festival, Brussels, Belgium.

1979

"Small Is Beautiful," Freedman Gallery, Albright College, Reading, Pennsylvania.
Center Gallery, Bucknell University, Lewisburg, Pennsylvania.
"Words," Museum Bochum, Bochum, Germany.
Palazzo Ducale, Genova, Italy.
"Stage Show," Museum of Modern Art Lending Service, New York City.

"10 Artists/Artists Space," Neuberger Museum, Purchase, New York.
"Kunstlerschaufenster, Steirischer Herbst" (Shop Windows by Artists), Germany.

1980

"Drawings: The Pluralist Decade," Venice Biennale (traveling: Denmark, Norway, Spain, Portugal); curator: Audrey Strohl, Venice, Italy.
"Beyond Object: A Contemporary Sculpture Exhibition," Aspen Center for the Visual Arts, Aspen, Colorado.
"Ecouter Par Les Yeux," Musée d'Art Moderne, Paris, France.
"Dream Sequences from United States," Language in the Visual Arts, New Jersey.

1981

"New York Studio Events," Independent Curators, Inc., New York City.
"Messages: Words and Images," Freedman Gallery, Albright College, Reading, Pennsylvania.
"Schemes, A Decade of Installation Drawings," Elise Meyer, Inc., New York City.
"Soundings," State University of New York, Purchase, New York.
"Language in the Visual Arts," School of Arts and Communication, William Paterson College, Wayne, New Jersey.

DATE DUE

GAYLORD			PRINTED IN U.S.A.